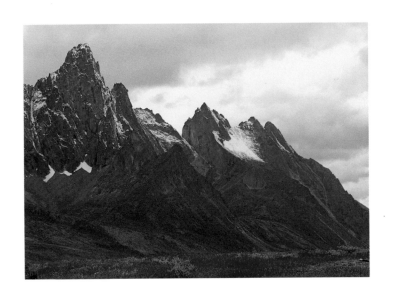

YUKON

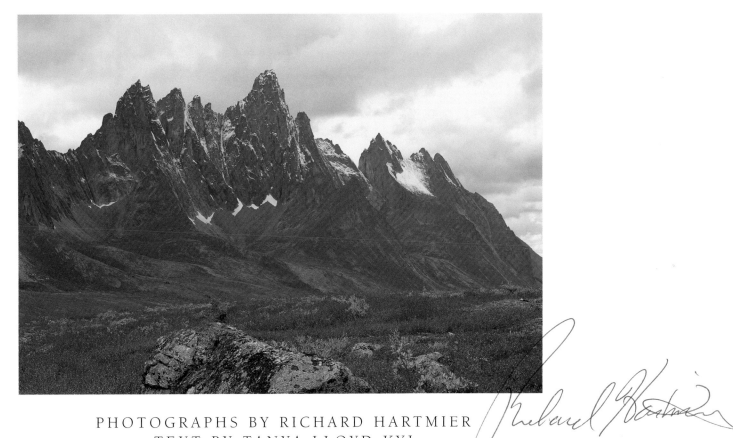

PHOTOGRAPHS BY RICHARD HARTMIER
TEXT BY TANYA LLOYD KYI

whitecap

Text by Tanya Lloyd Kyi
Edited by Elaine Jones
Photo editing by Tanya Lloyd Kyi
Proofread by Lisa Collins
Cover and interior design by Steve Penner
Typesetting by Maxine Lea

Printed and bound in Canada by Friesens.

National Library of Canada Cataloguing in Publication Data

Lloyd, Tanya, 1973–
 Yukon
 ISBN 1-55285-181-8
 1. Yukon Territory—Pictorial works. I. Title.
FC4012.L56 200166 1999971.9'103'022266 1999C2001-910093-0
F1091.L56 2001

The publisher acknowledges the support of the Canada Council and the Cultural
Services Branch of the Government of British Columbia in making this publication
possible. We acknowledge the financial support of the Government of Canada through
the Book Publishing Industry Development Program for our publishing activities.

For more information on the Canada Series and other titles by Whitecap Books,
please visit our website at www.whitecap.ca.

More than a century ago, stampeders swarmed into the Yukon, arriving by steamer and on foot over the Chilkoot and White passes. Where the Yukon and Klondike rivers met, near the newly named Bonanza and Eldorado creeks, a tent city, then a town, sprang up almost overnight. Dawson City earned the status of Paris of the North within a few years of the first gold strike, as still more fortune seekers poured into the Klondike, some to mine the creeks and some to cater to the miners.

Suddenly, the Yukon was no longer simply the northern home of First Nations and fur traders. For a few short years, it was in the world's spotlight. Cities such as Whitehorse and Carmacks boomed as supply depots on the route to the gold fields, luxury sternwheelers churned down the rivers, and entrepreneurs planned railways and cargo routes for ore and supplies.

The Klondike's glory days were short-lived. A few years after the initial strike, boom was turning to bust. A gold strike in Alaska drew thousands of prospectors further west and professional companies took over in the Yukon. But the miners who went elsewhere left behind ornate false-fronted hotels, abandoned tumble-down shacks on glacier-fed creeks, and legends of dance hall days and instant millions.

Today, these stories and the much-photographed landscapes of the Yukon have brought a new kind of stampede—not prospectors this time, but sightseers and thrill seekers. Thousands flock north each year to wander Dawson's historic streets, tour an authentic sternwheeler in Whitehorse, and ride the White Pass and Yukon Railway towards the peaks. Cyclists arrive to challenge the gruelling but spectacular curves of the Dempster Highway. Kayakers shoot the Five Finger Rapids and hikers don crampons to scale the slopes of the St. Elias Mountains.

Along with the reminders of the gold rush, it's the wilderness that draws these travellers. While most of North America has been criss-crossed by roads and railways, dotted with communities, 80 percent of the Yukon remains virgin territory. In these pages you'll find landscapes untouched since the glaciers of the last ice age retreated 13,000 years ago.

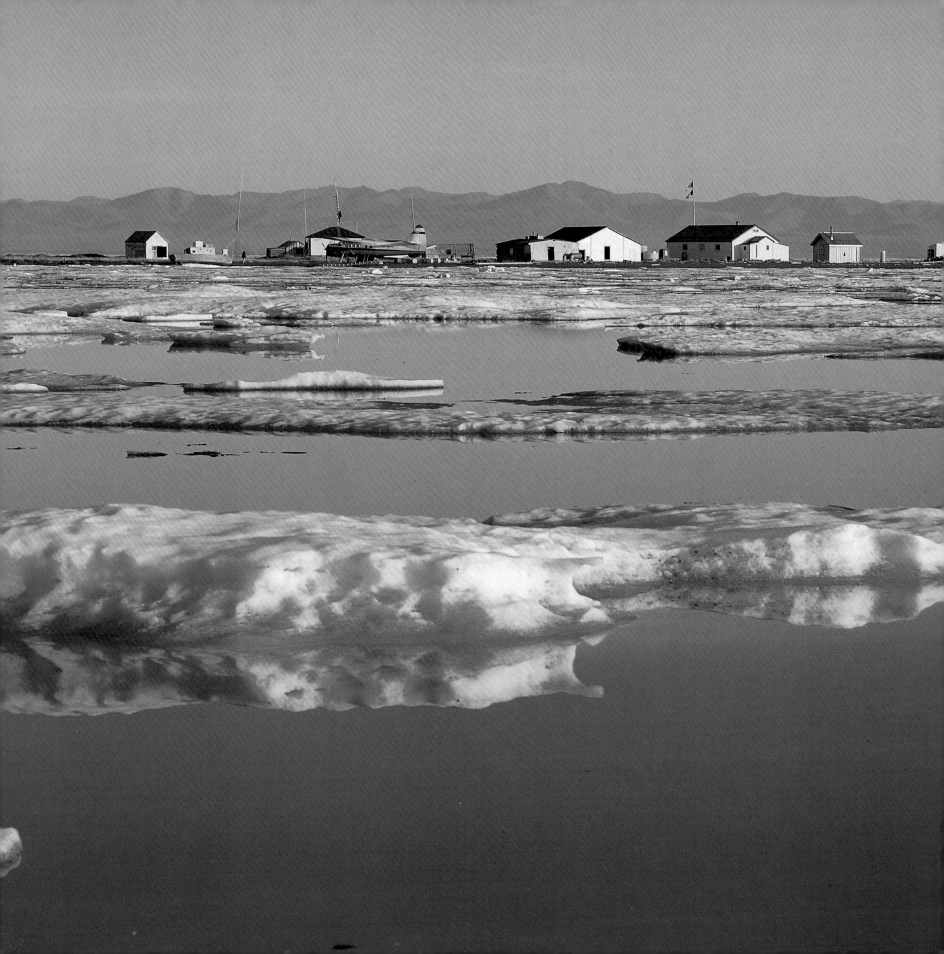

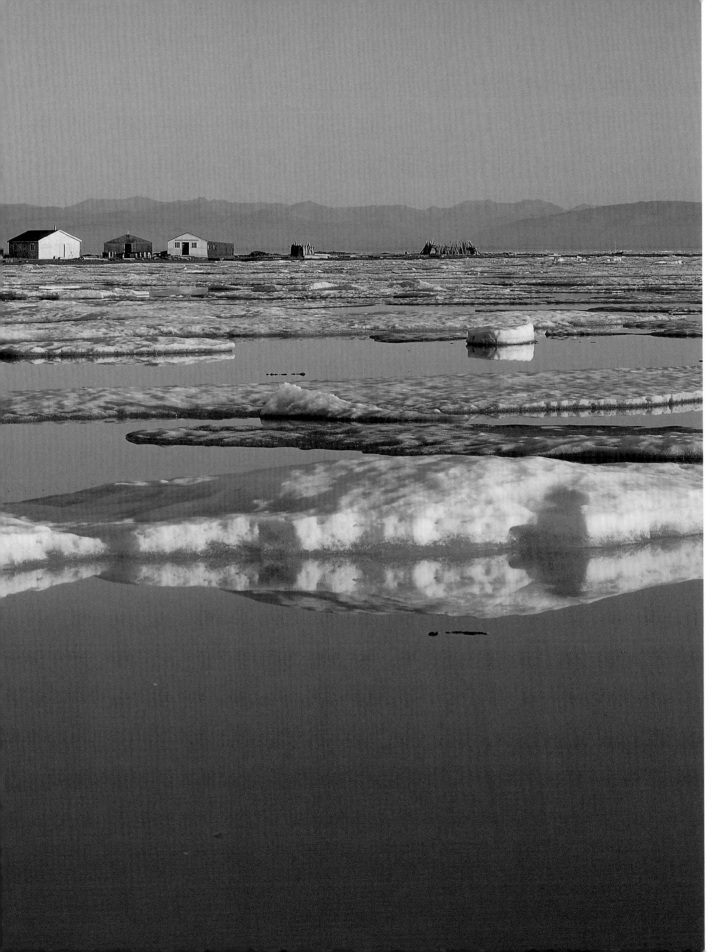

Qikiqtaruk Park, also known as Herschel Island, lies in the Beaufort Sea just a few kilometres away from the Arctic's permanent pack ice. Home to 200 species of plant life, the park is jointly managed by the government and the Inuvialuit people.

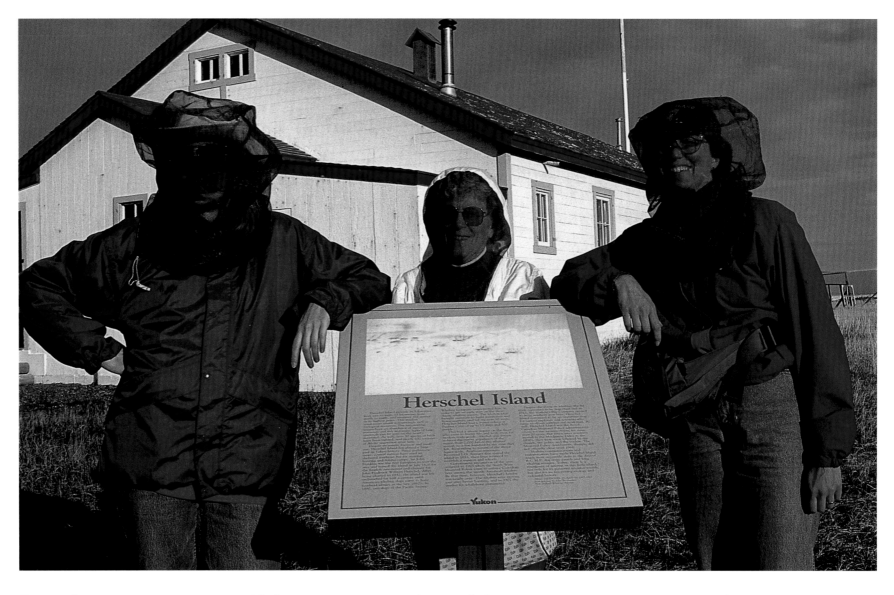

Draped in netting, visitors avoid the summer mosquitoes while exploring Herschel Island's history. Once an Inuvialuit settlement, the island later served as a base for whalers. It was declared the Yukon's first territorial park in 1987.

A rainbow arches through the half-dusk that passes for summer nightfall within the Arctic Circle. Much of the Yukon's far north is protected by Ivvavik National Park, a 10,000-square-kilometre (3,860-square-mile) preserve adjoining the Alaska border.

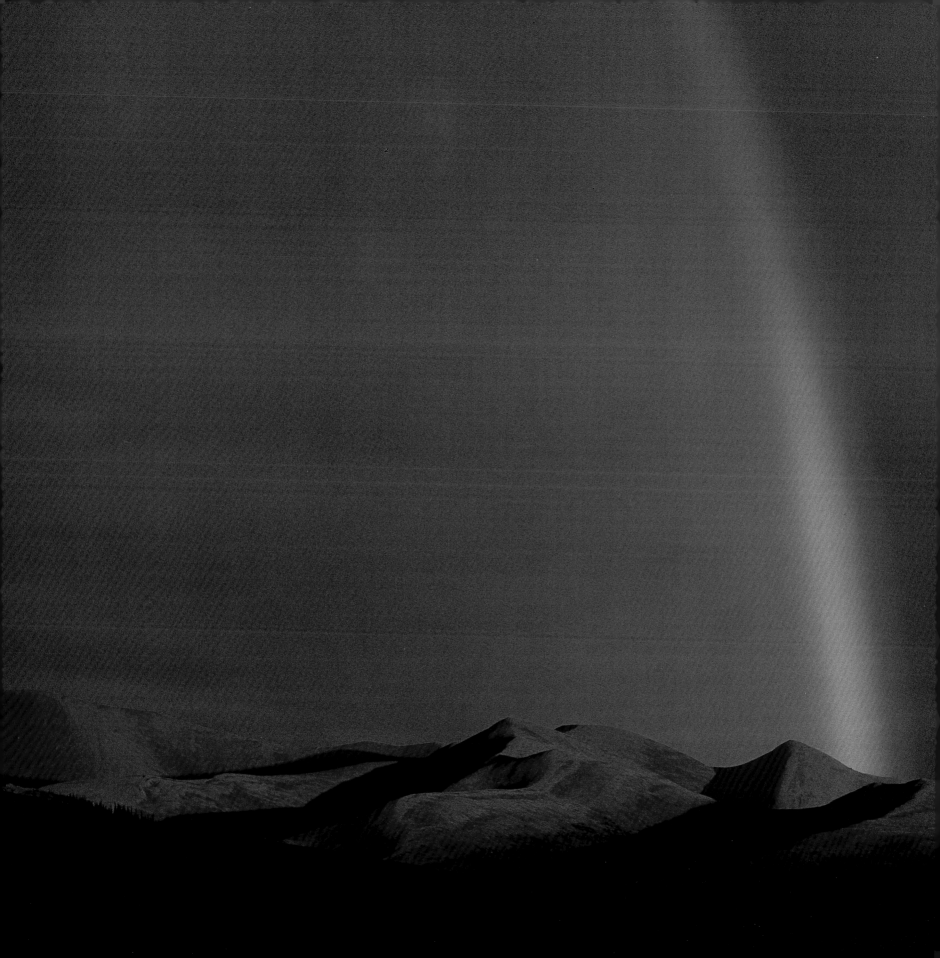

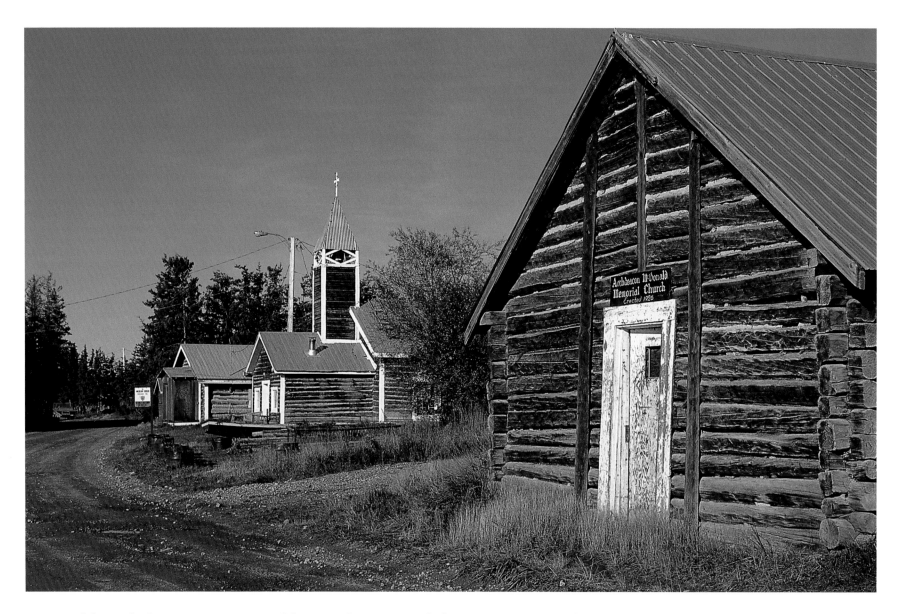

Accessible only by air or water, Old Crow lies 1,000 kilometres (620 miles) north of Whitehorse, above the Arctic Circle. In the mid-1800s, this was an active fur-trading region, but when most of the population was decimated by smallpox in the early twentieth century, survivors established Old Crow at the junction of the Old Crow and Porcupine rivers.

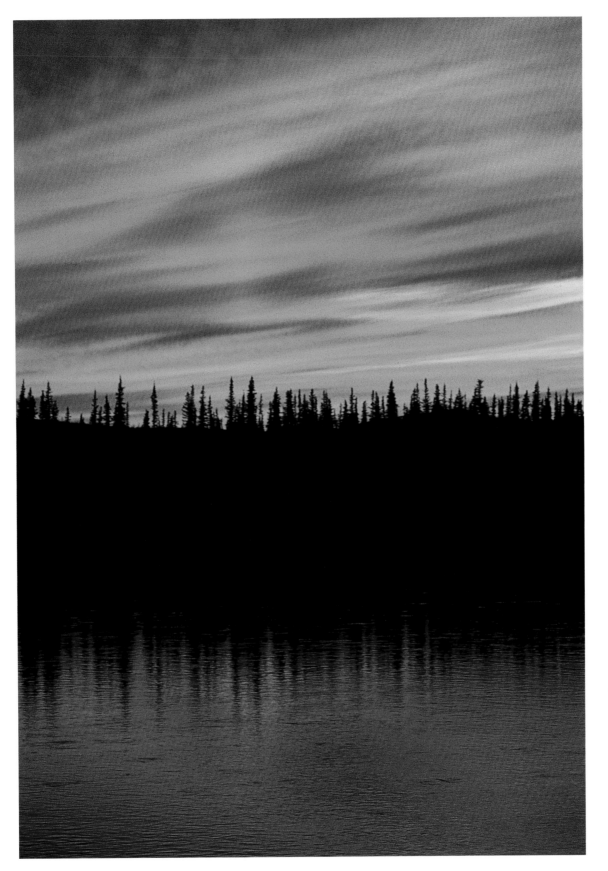

The Porcupine River is ice-free for only a third of the year. Flowing through the Yukon's northern reaches, the river is near the centre of the Porcupine caribou herd's massive range.

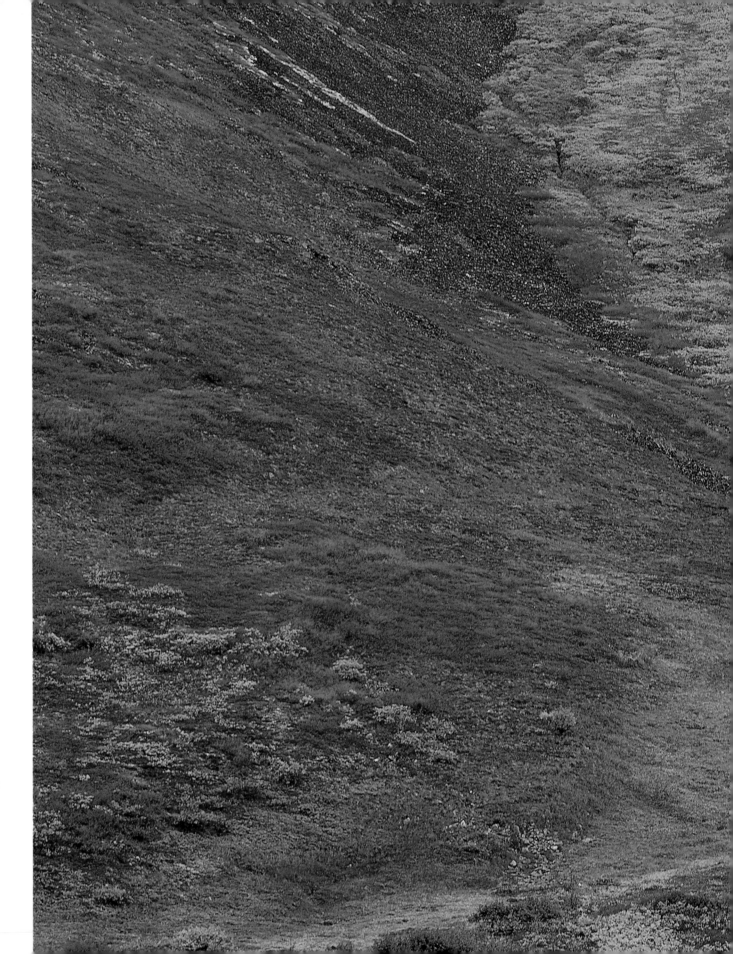

The Richardson Mountains, named for Franklin expedition member John Richardson, rise from the valleys to 1,753-metre (5,750-foot) spires. Like about a quarter of the Yukon's land mass, the Richardson Mountains are carpeted in tundra.

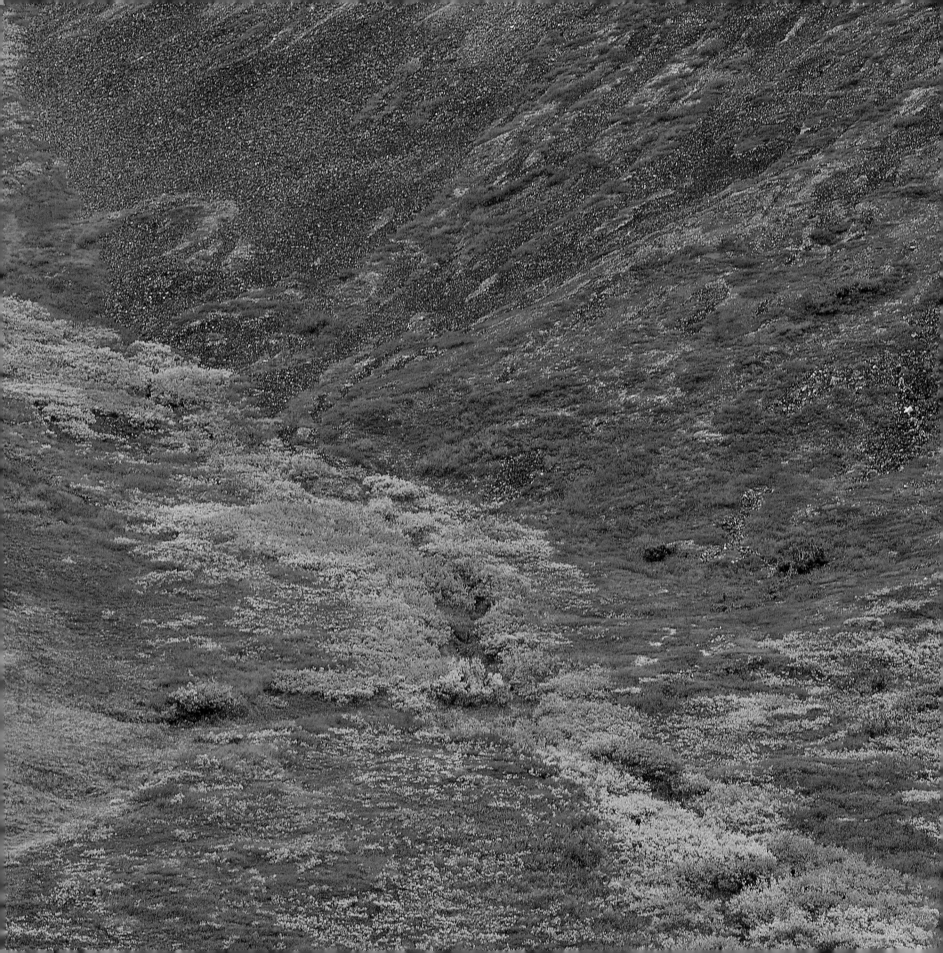

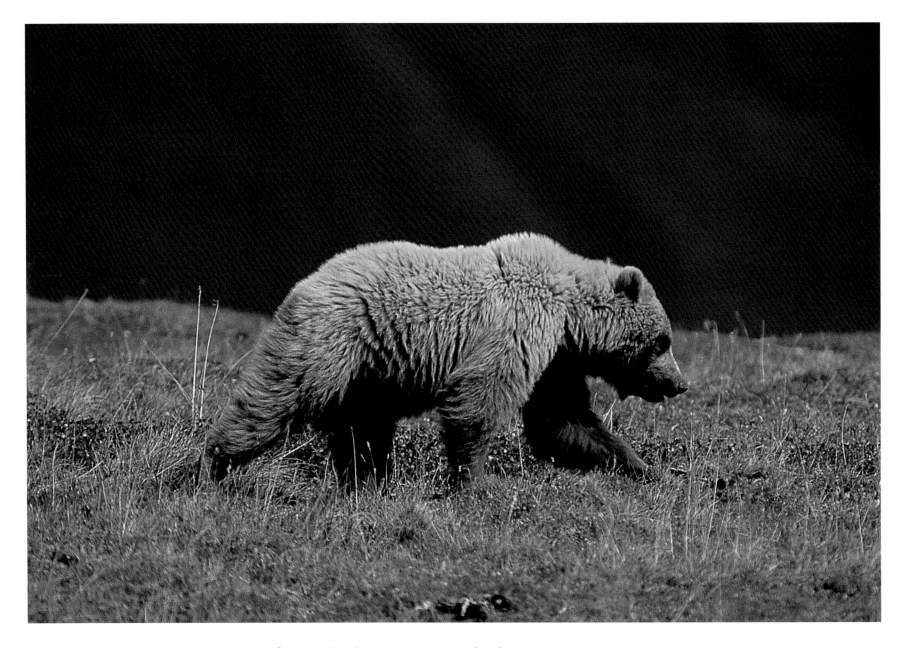

The Yukon is home to all three of Canada's bear species. Polar bears wander the shores of the Beaufort Sea, while grizzlies and black bears roam vast territories of forest and tundra in search of food.

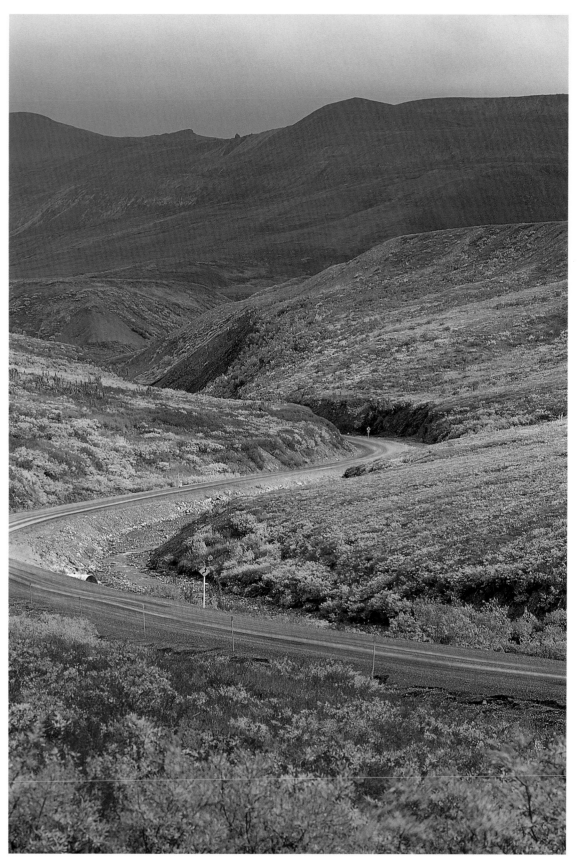

The Dempster Highway follows some of the dog sled routes taken by early North-West Mounted Police patrols. Corporal W. J. D. Dempster led a team through this land in search of a lost patrol in 1911. He found them, killed by hypothermia and starvation, just 56 kilometres (35 miles) from where they began.

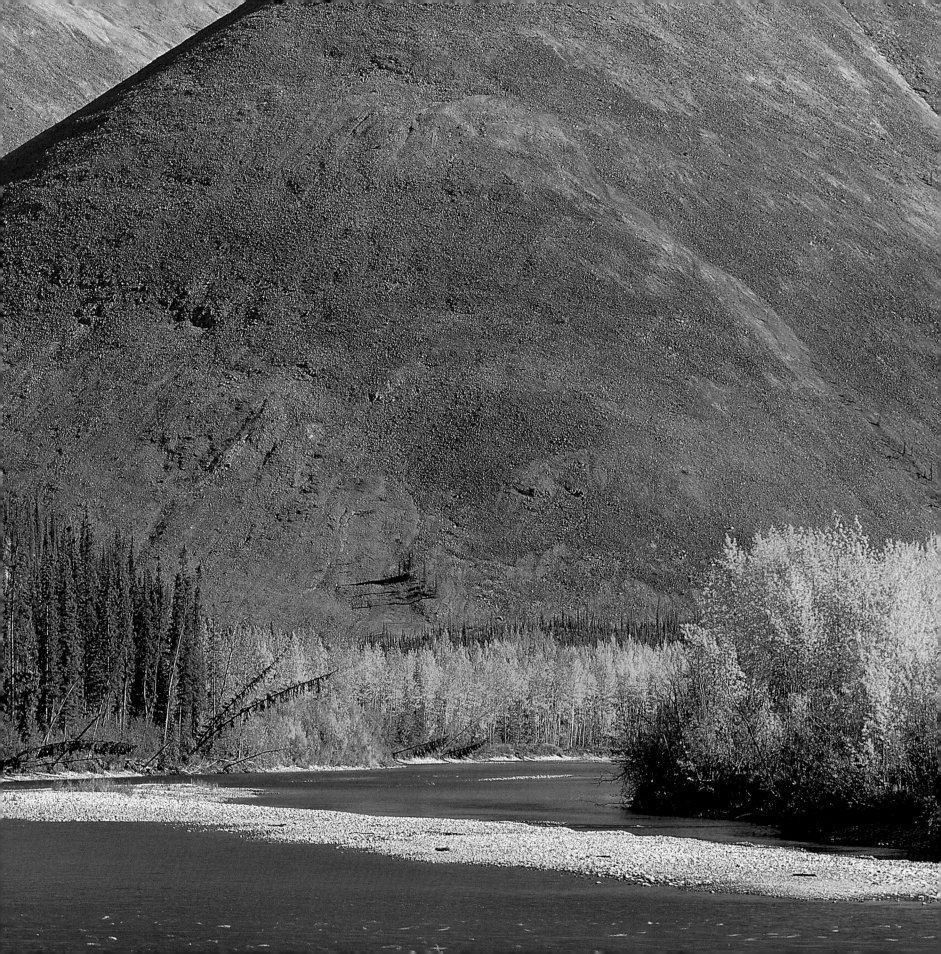

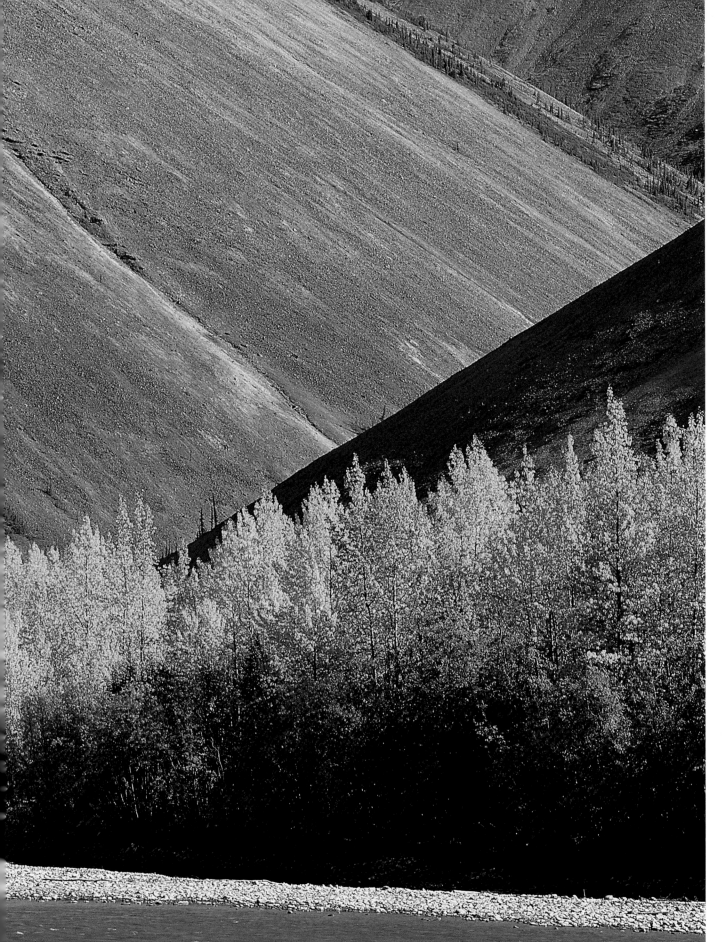

Travellers on the
Dempster Highway
gain views of the
Ogilvie River. Stretch-
ing from just east
of Dawson to the
Northwest Territories,
the 741-kilometre
(460-mile) Dempster
Highway is Canada's
only highway to cross
the Arctic Circle.

17

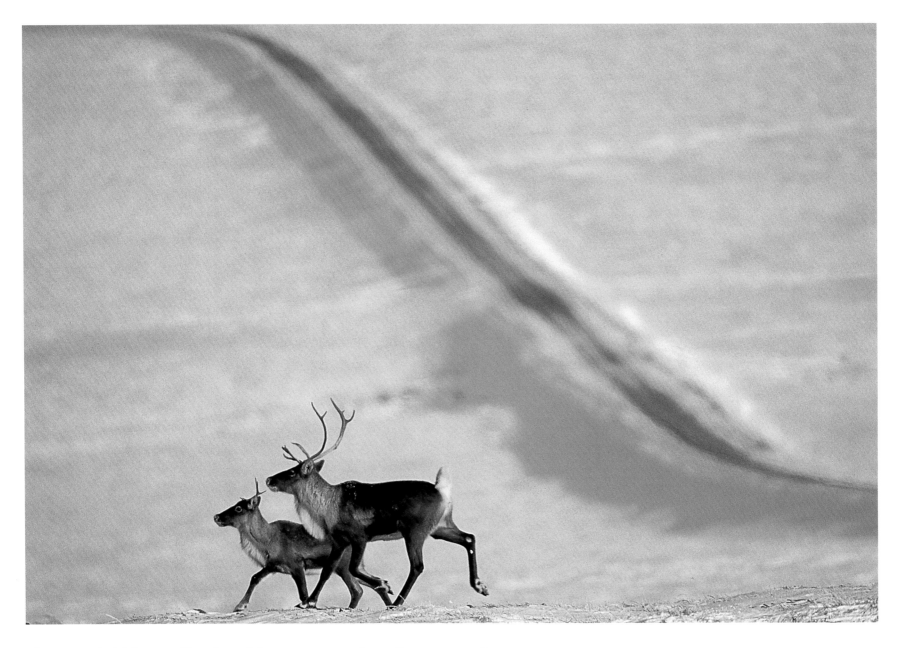

About 250,000 woodland and barren-ground caribou roam the Yukon. This female and her calf will spend the winter using their hooves to clear the snow and reach the edible lichens below.

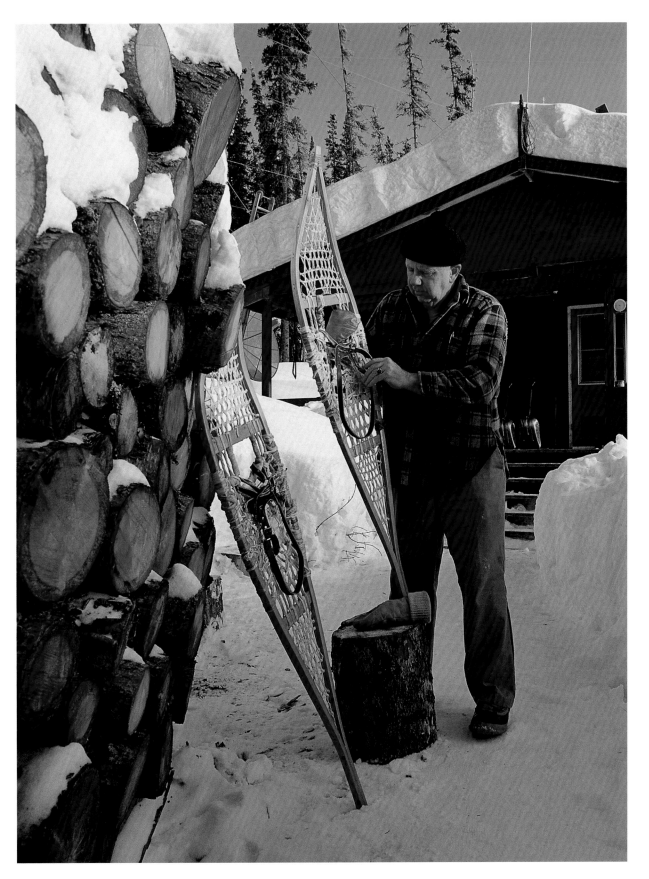

With only one city and three incorporated towns, the Yukon is a territory of tiny settlements and wilderness retreats. Those who make their homes in the more isolated communities must be ready to face harsh winter conditions with little outside help.

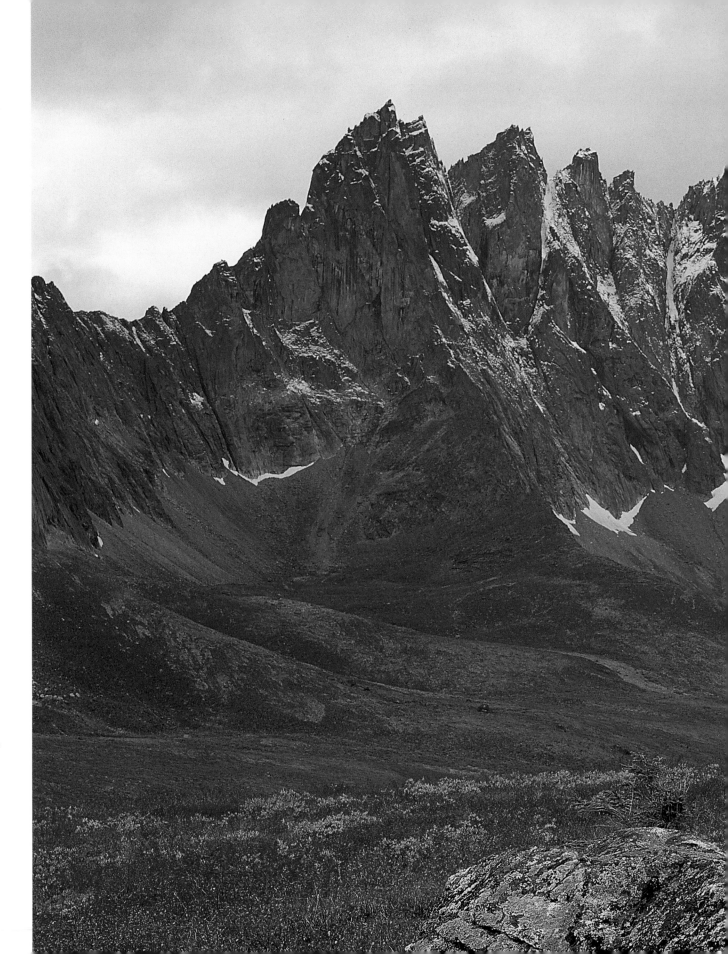

Recently protected as parkland, the Tombstone Mountains are home to 23 distinct ecosystems, one of the most diverse varieties of life in the north.

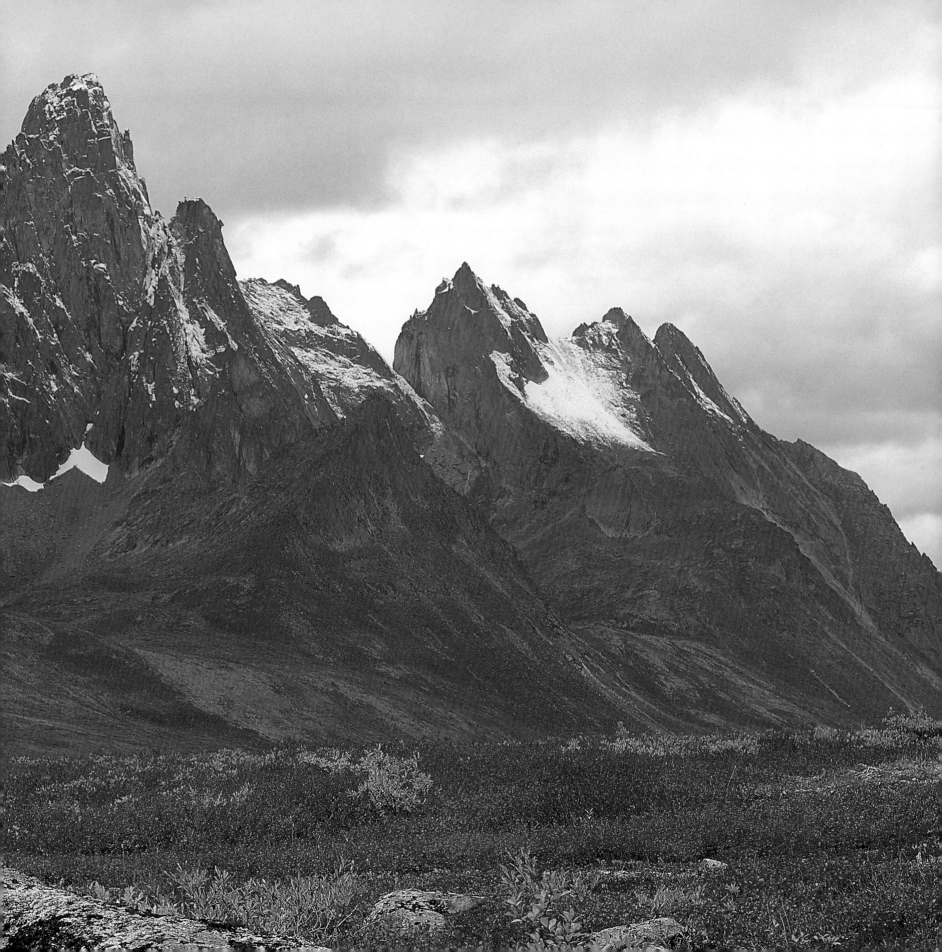

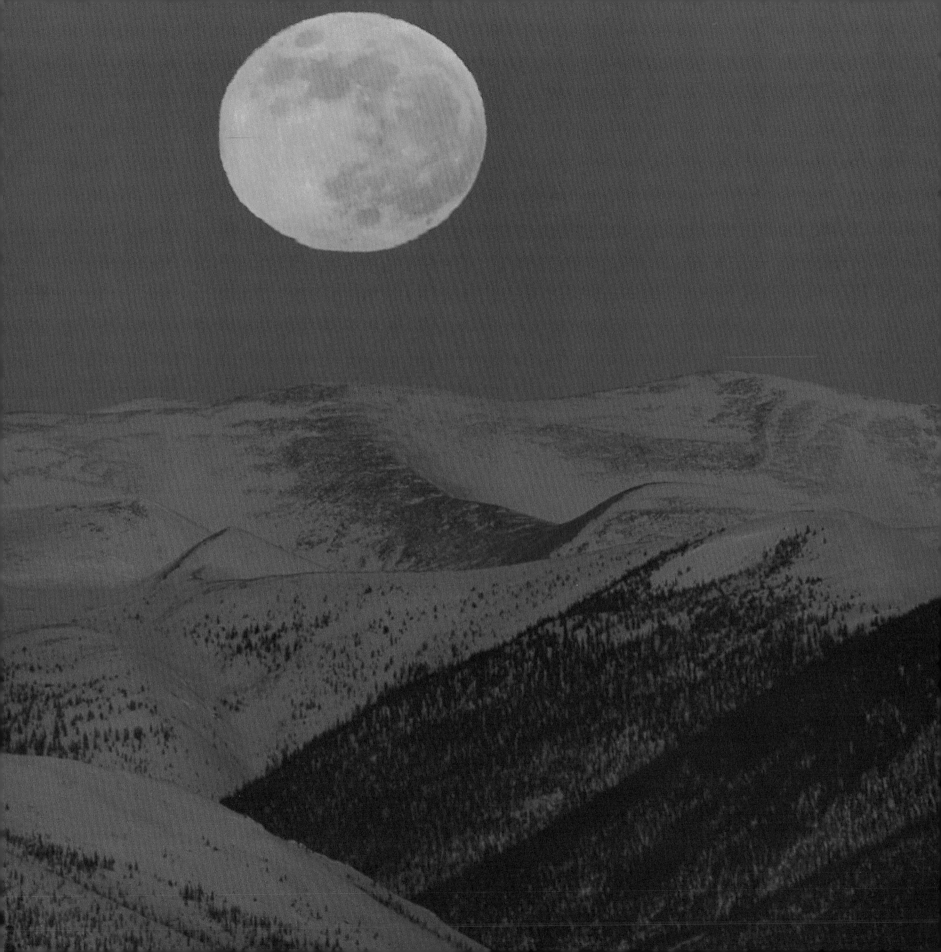

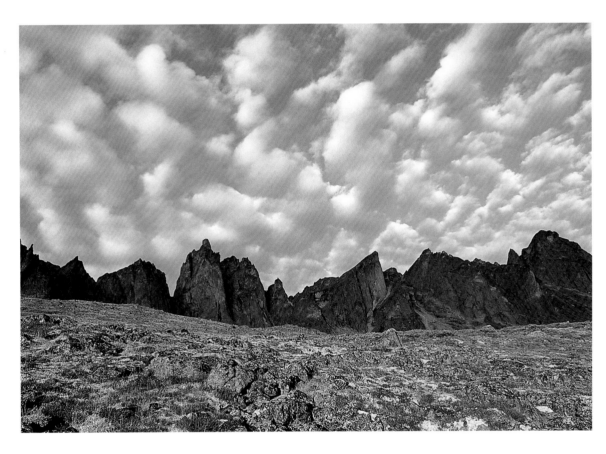

Historians believe people travelled this land more than 20,000 years ago, following herds of mammoth and bison across the Bering land bridge through Alaska and into what is now the Yukon. Parts of the Ogilvie Mountains and the Tombstone Valley remained ice-free, providing a wide corridor south.

Permanently frozen ground, known as permafrost, lies just beneath the tundra in much of the Yukon. Mammoth remains discovered intact and preserved prove that some of this land has remained frozen since the time of the last ice age.

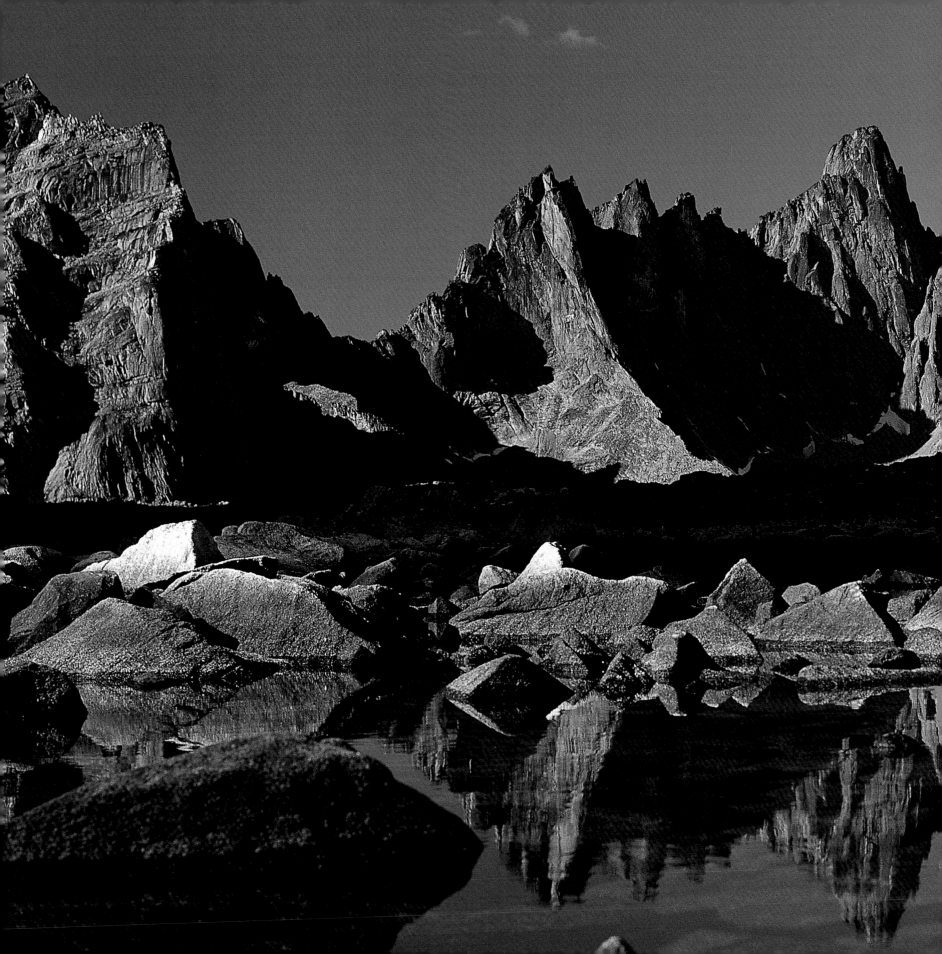

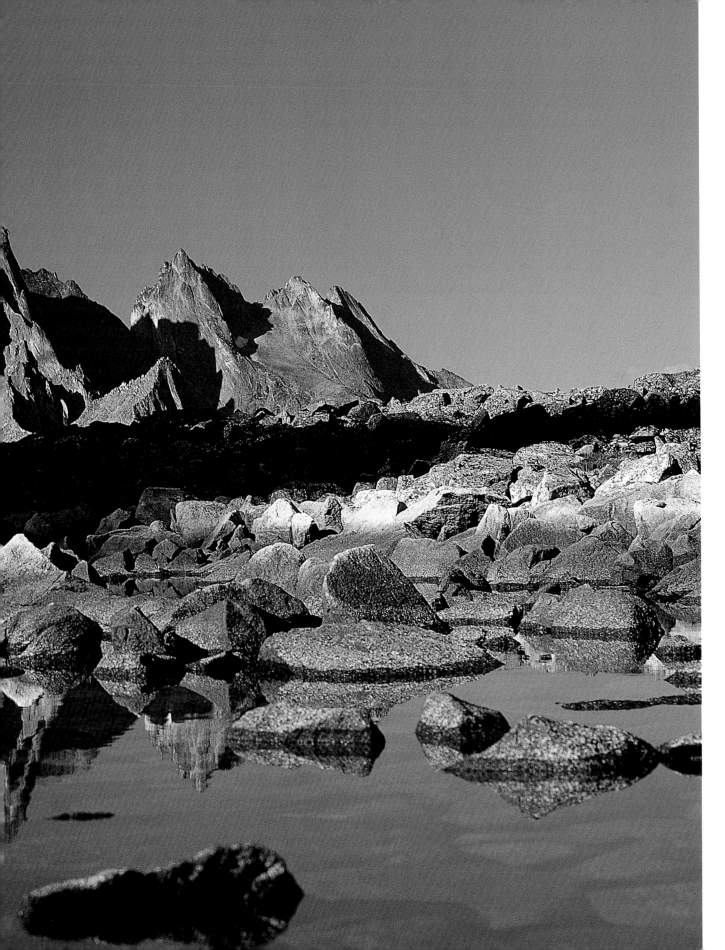

Hudson's Bay Company fur traders arrived in the Yukon as early as 1848, but extreme isolation and the difficulty of transporting furs to the European market meant the company's outposts were often short-lived.

About 80 percent of the Yukon remains uninhabited, an astoundingly vast refuge for wildlife and wilderness. About 280,000 square kilometres (108,000 square miles) of this land is forested; much of the rest is rolling tundra.

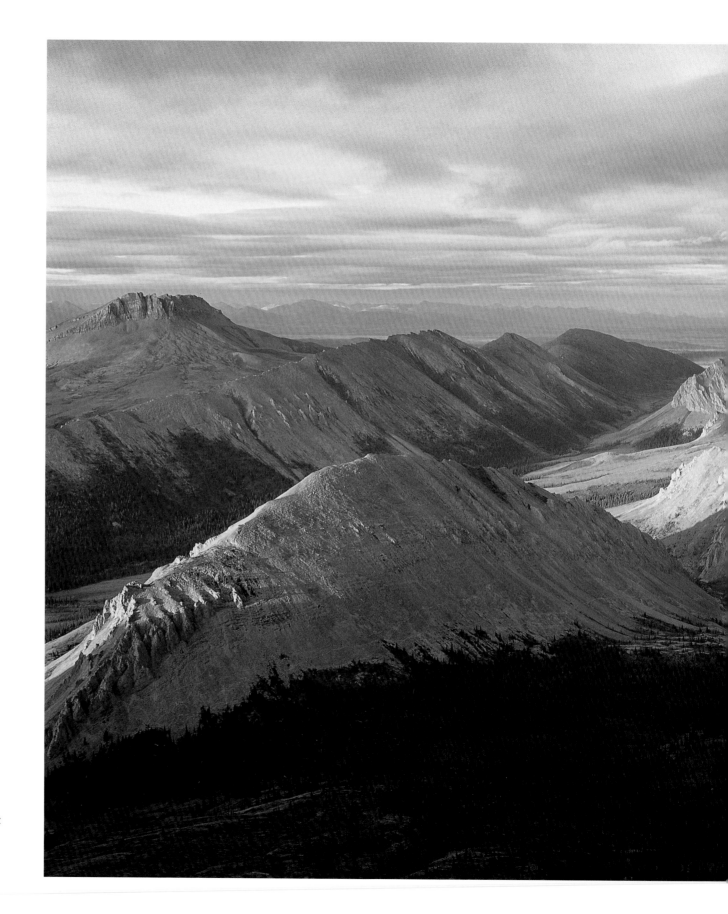

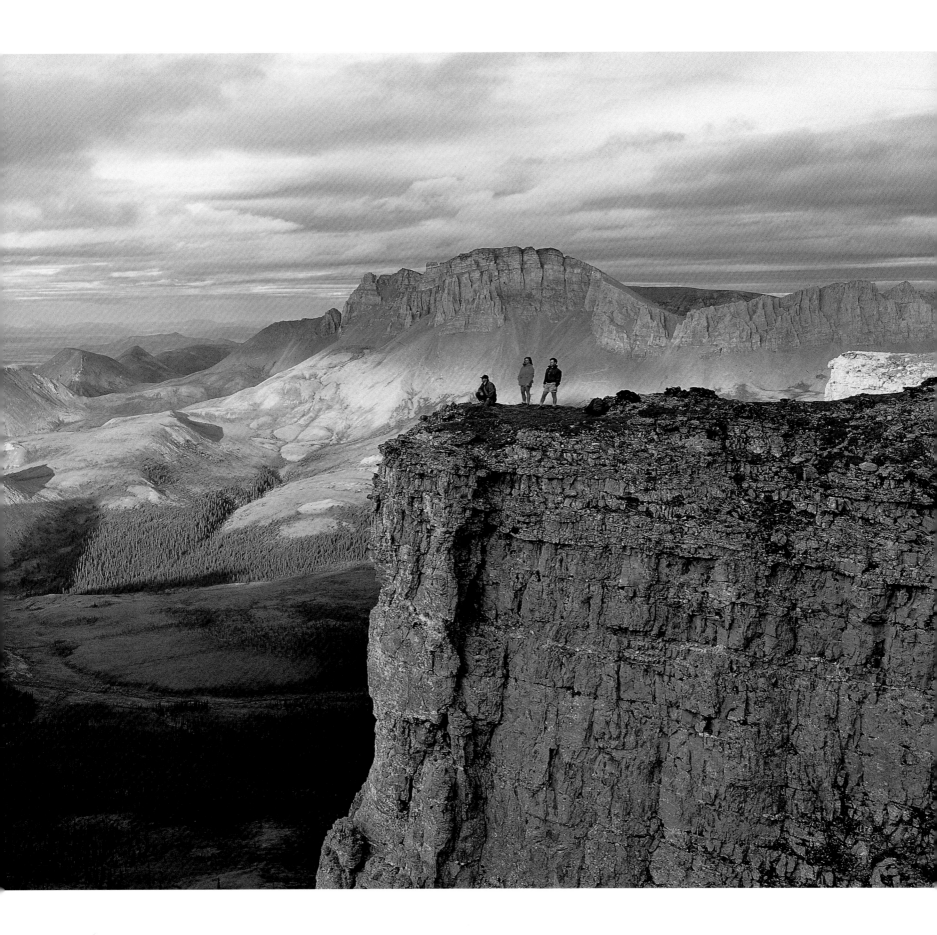

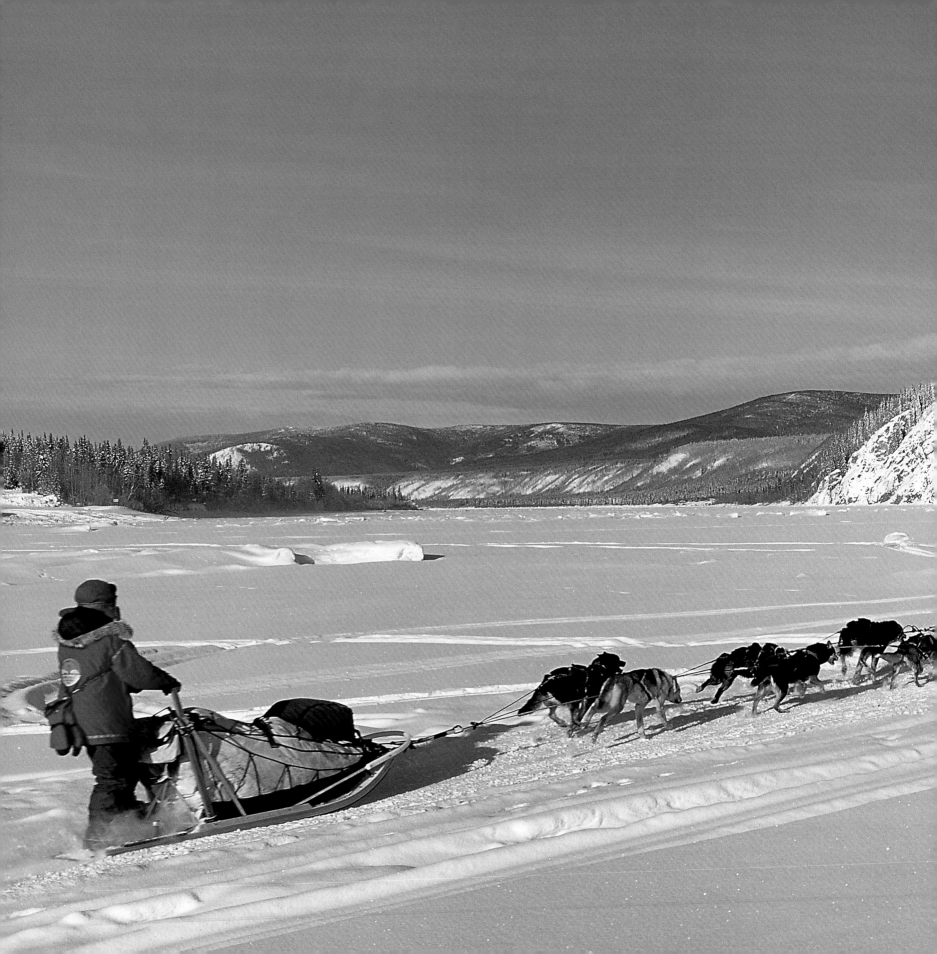

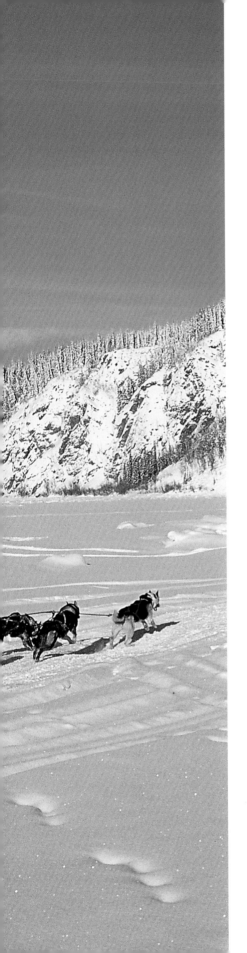

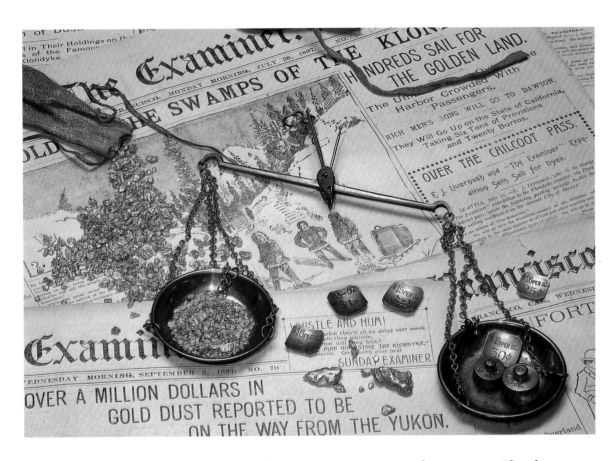

In 1896, George Carmack, Skookum Jim Mason, and Dawson Charlie discovered gold on Rabbit Creek, which they immediately renamed Bonanza. Papers across the continent carried news of their find, prompting an unprecedented stampede to the Klondike.

Dog teams were essential to the Yukon's First Nations people for centuries, and the sleds were quickly adapted by the European explorers and fur traders who reached the region. Today, snowmobiles cover distances more quickly, and dog-sledding is mainly recreational.

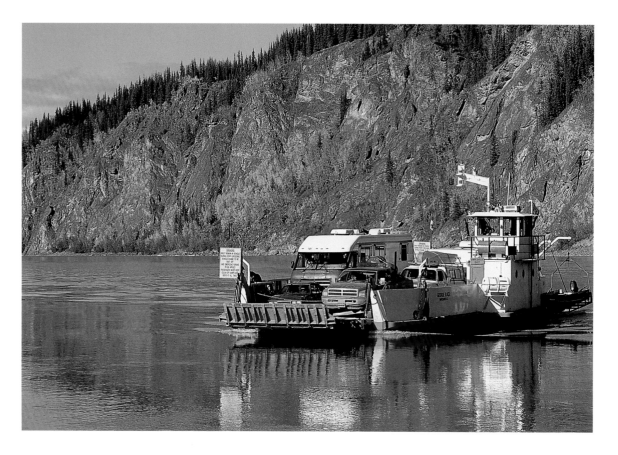

The George Black Ferry is named for one of the Yukon's most popular leaders. The Commissioner of the Yukon in the early 1900s, George Black later resigned his post to fight in World War I. In 1921, he was elected the member of parliament for the territory, a position later to be held by his wife, Martha Louise Black.

Enormous dredges allowed miners to access the gravel of the riverbeds, often richer than the sediment along the banks. One machine in the Klondike extracted more than 200,000 kilograms (7.5 million ounces) between 1928 and 1959.

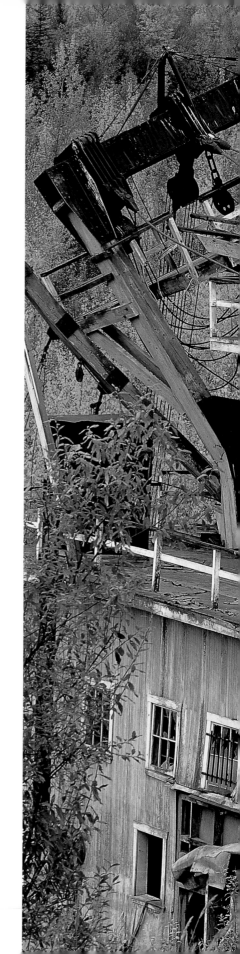

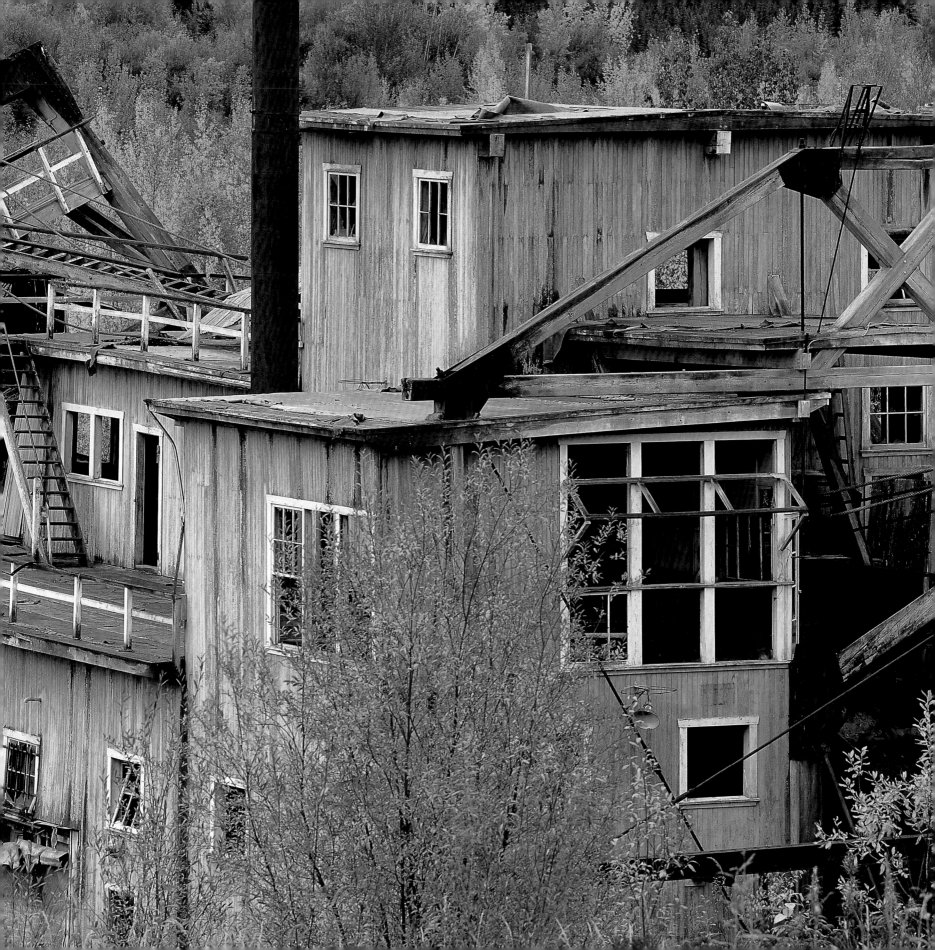

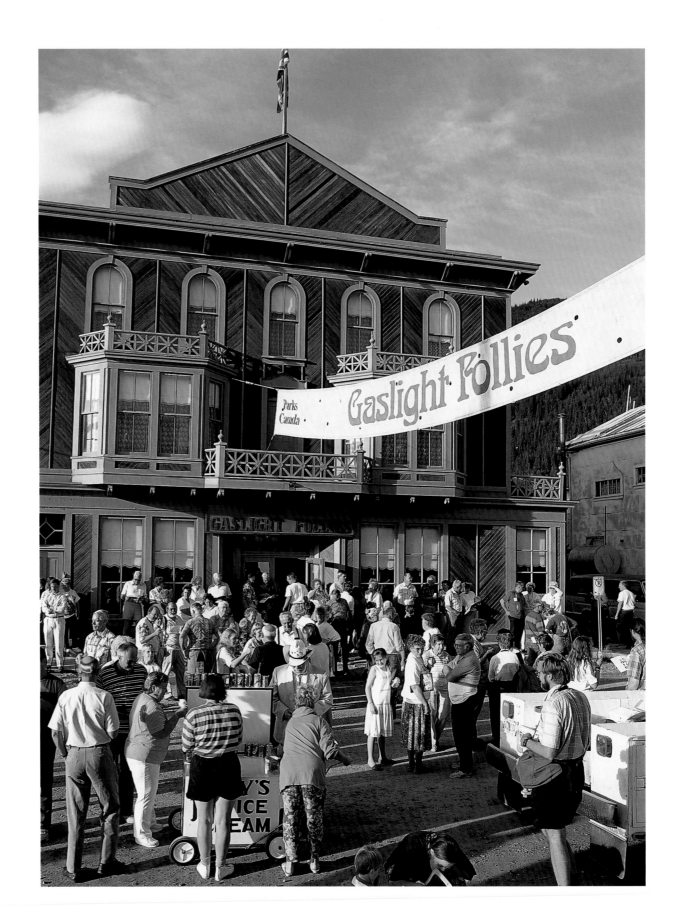

By 1899, Dawson had boomed, becoming the largest city west of Winnipeg and north of San Francisco. About 15,000 fortune seekers worked the region's creeks for gold.

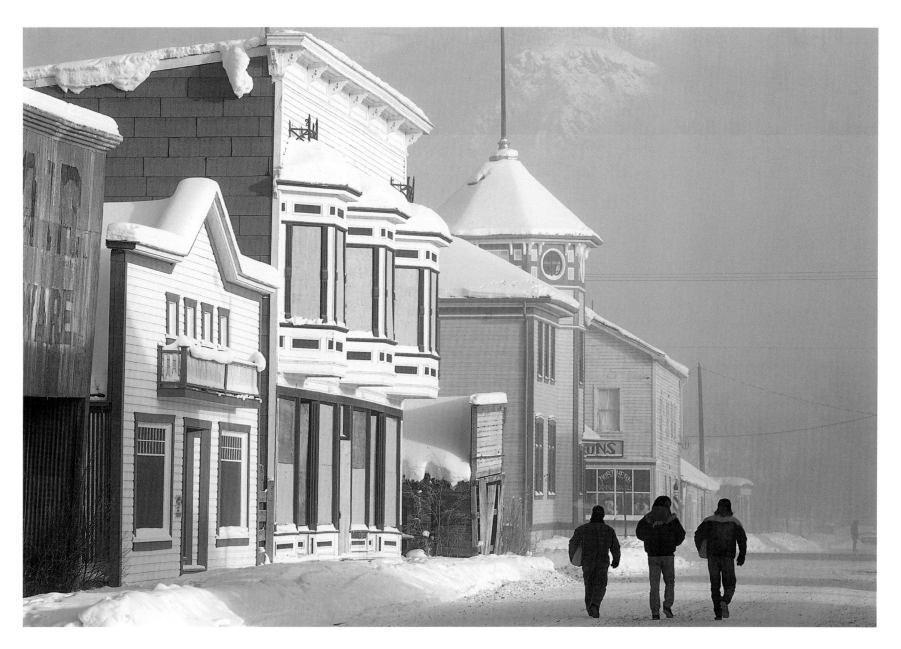

By 1898, Dawson boasted telephone services, running water, and steam heat systems, but winter still brought almost total isolation to the northern settlement. Ships could no longer ply the ice-bound rivers and residents went without supplies and mail for several months.

About 2,000 people live in Dawson today, but the city experiences a new kind of boom each summer, when more than 60,000 visitors arrive to explore the region.

FACING PAGE—
Declared a National Historic Site in the 1960s, Dawson City boasts 35 restored homes and businesses and offers visitors a realistic glimpse of life during gold rush days.

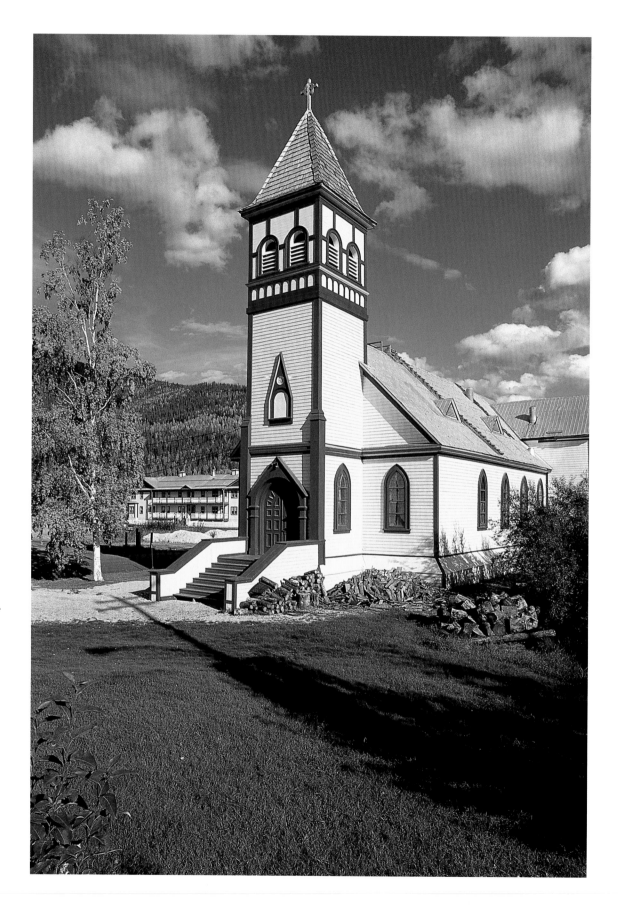

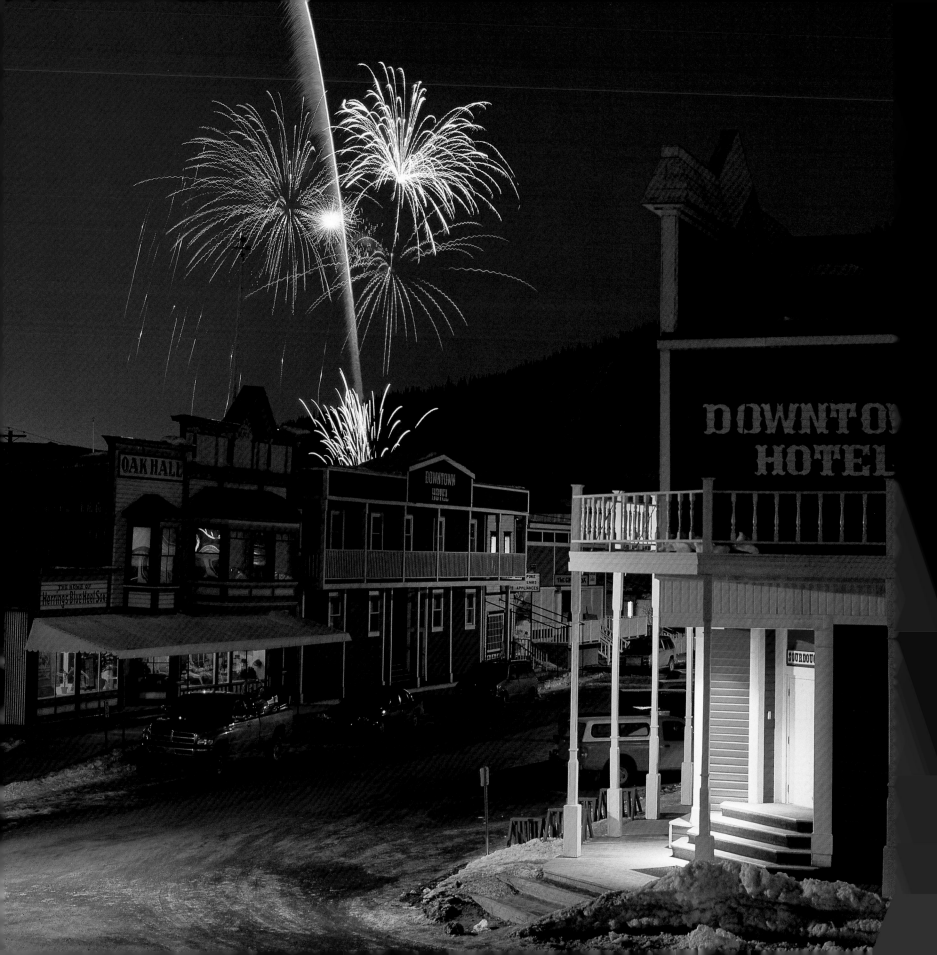

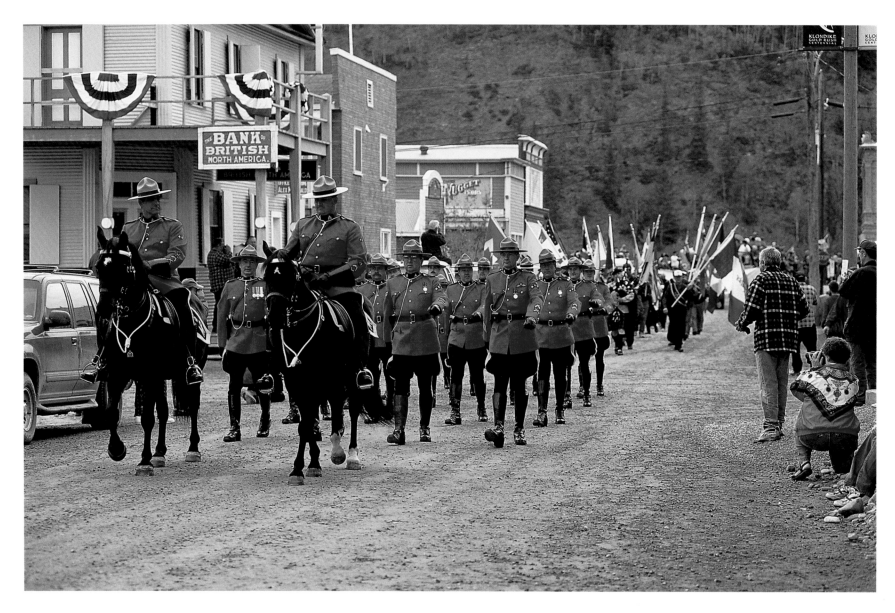

RCMP officers take part in the annual Discovery Days parade in Dawson. About 200 members of the North-West Mounted Police arrived here in 1898. Despite the saloons and dance halls, this was one of the safest cities on the continent. There was not one murder the year the Mounties arrived.

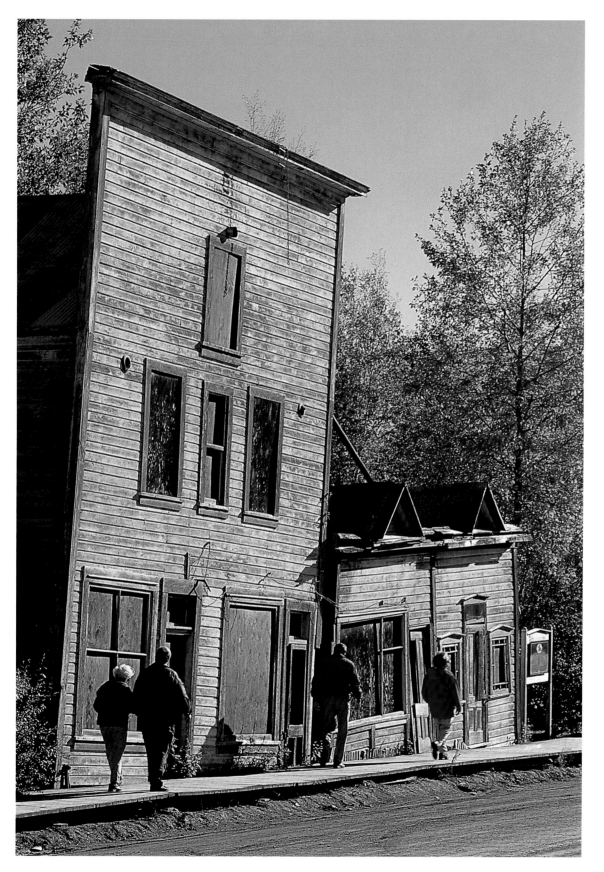

Between 1897 and 1900, four fires swept through Dawson, destroying the mainly wood-framed buildings. In the following decade, builders incorporated iron and tin and the city improved its fire-fighting services and equipment.

Visitors test their gold-panning skills at a working mine near Dawson. At the start of the gold rush, they would have needed a healthy store of nuggets to settle in Dawson. Land that had once sold for $10 an acre (.4 hectare) was selling fast at $1,000 per lot. On Front Street, entrepreneurs snapped up commercial lots for up to $40,000.

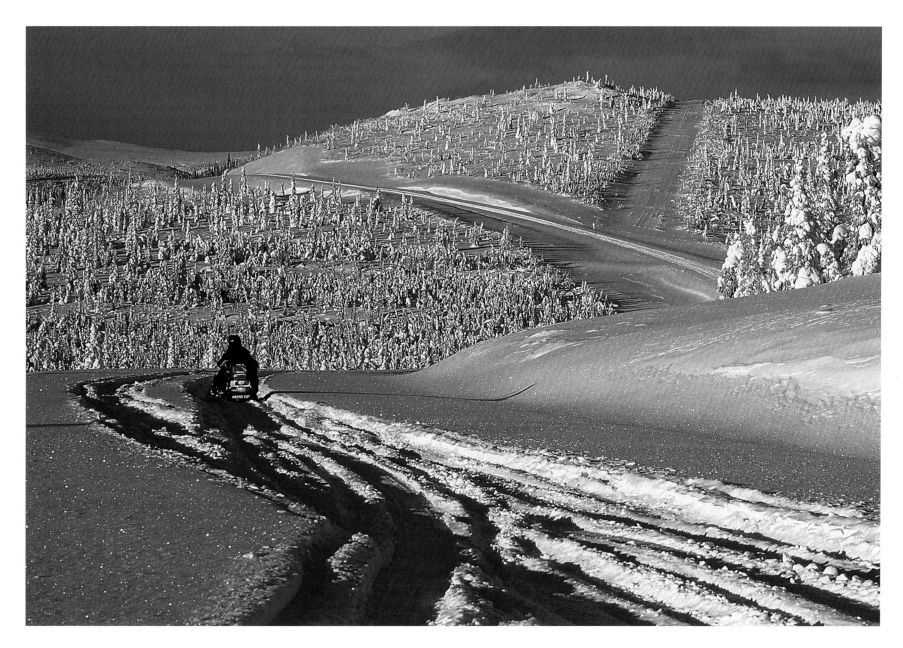

More than 500 snowmobilers gather each winter at Top of the World Highway to participate in the Trek over the Top. Along with organized race routes such as this one, countless recreation trails crisscross the territory.

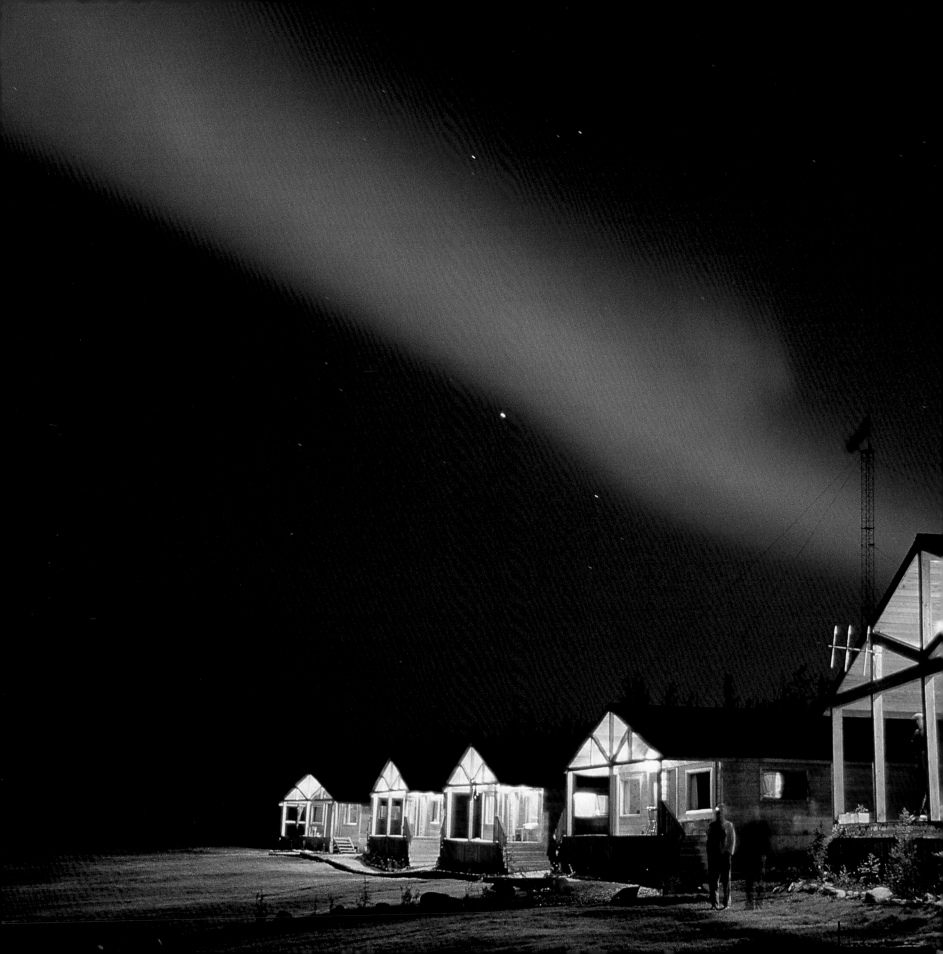

From late summer until spring, the blue, red, and green of the northern lights dance above the horizon. Caused by particles in solar wind hitting the earth's atmosphere, the lights dazzle 95 to 130 kilometres (60 to 80 miles) above the earth.

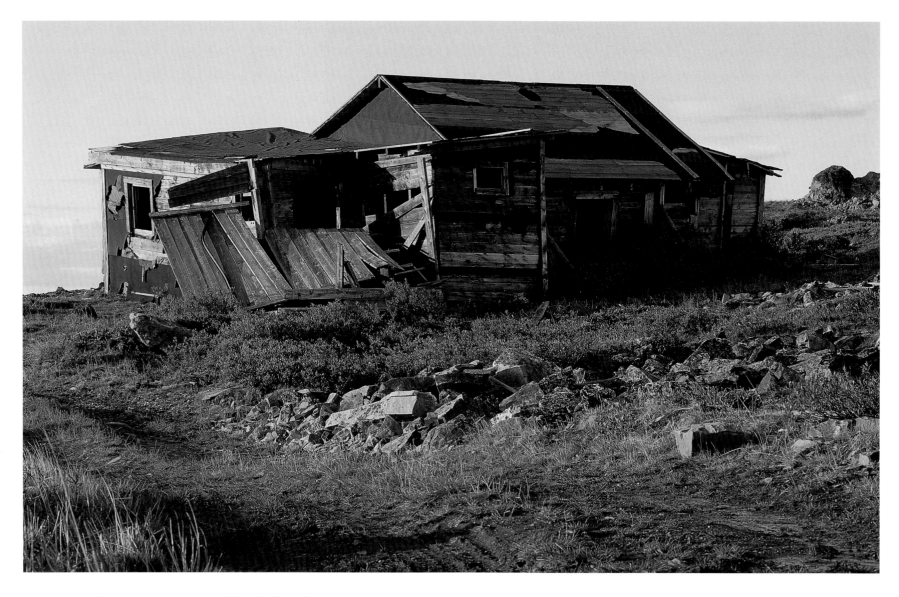

Keno's isolation made it difficult for the miners to ship their ore to market. Even after a rail line was built in 1922, fluctuations in world ore prices prompted a series of booms and busts.

Prospector and gambling man Louis Beauvette named this hill Keno in 1919, after a betting game played in mining camps. A year later, fortune seekers staked 600 claims around the hill and began mining silver and lead.

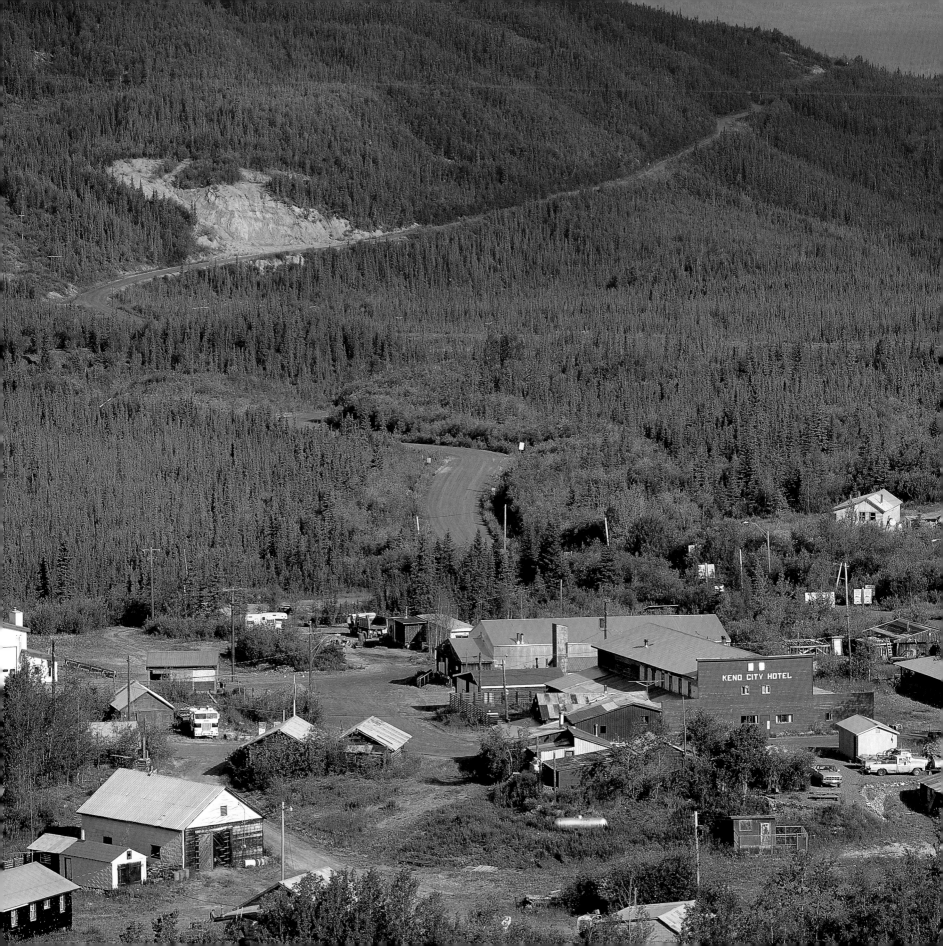

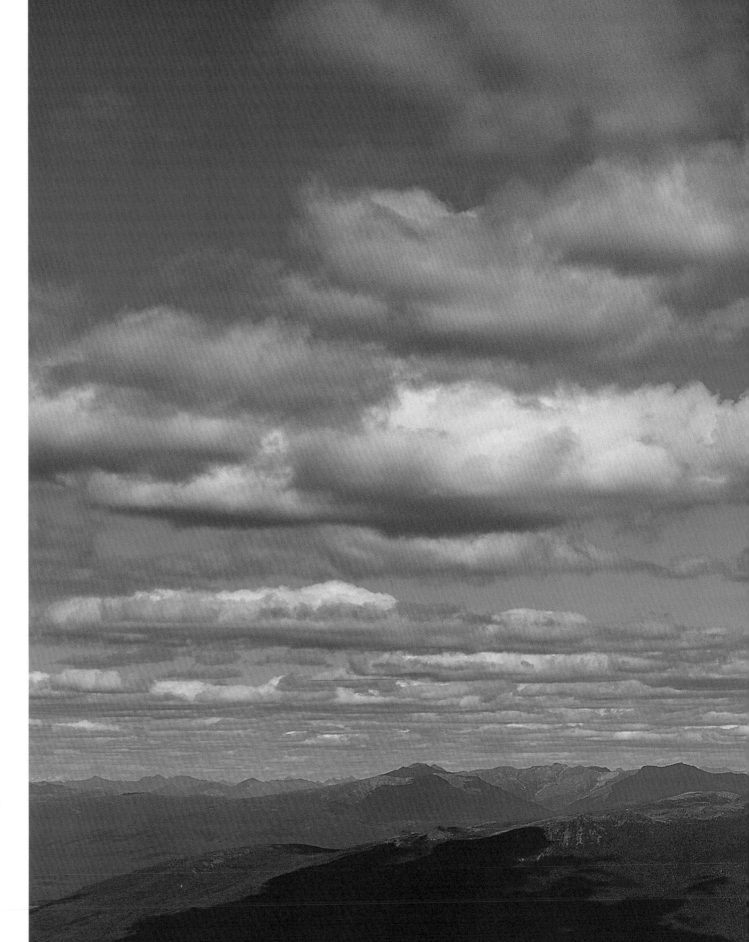

Few travellers ever see this signpost on Keno Hill. The town is a ghost of its former gold rush self, and only a small mining museum continues to draw visitors.

44

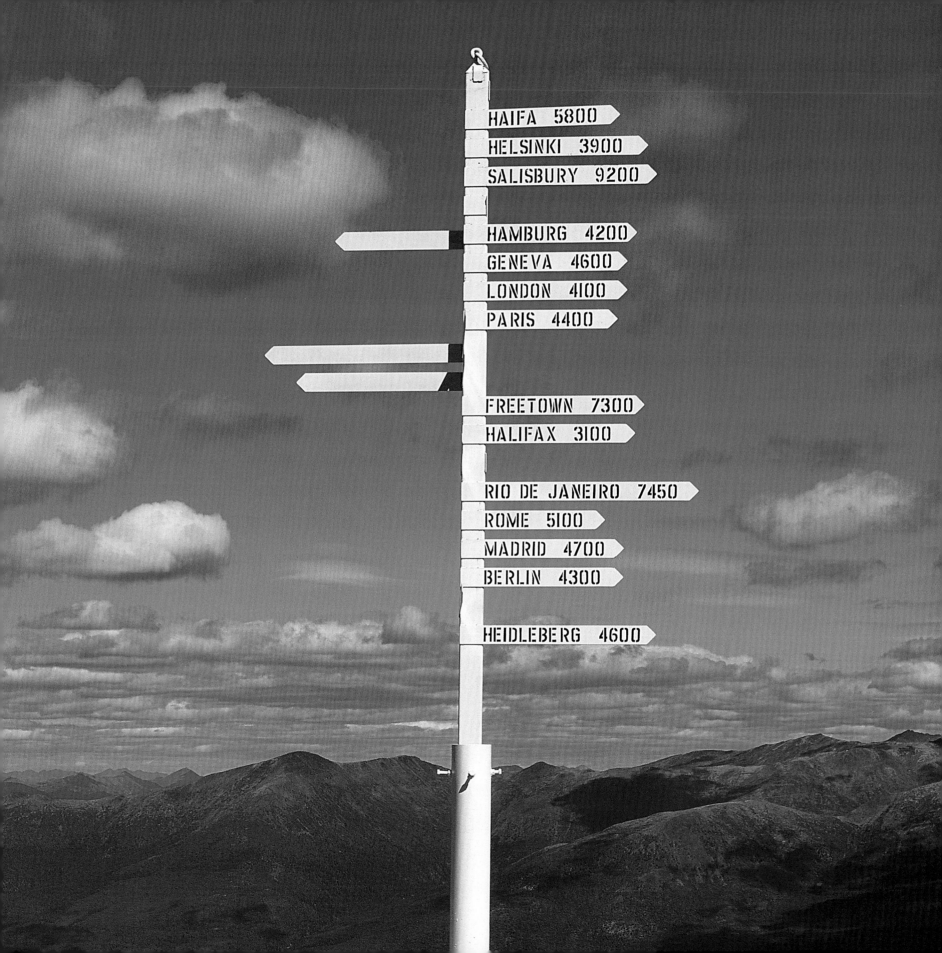

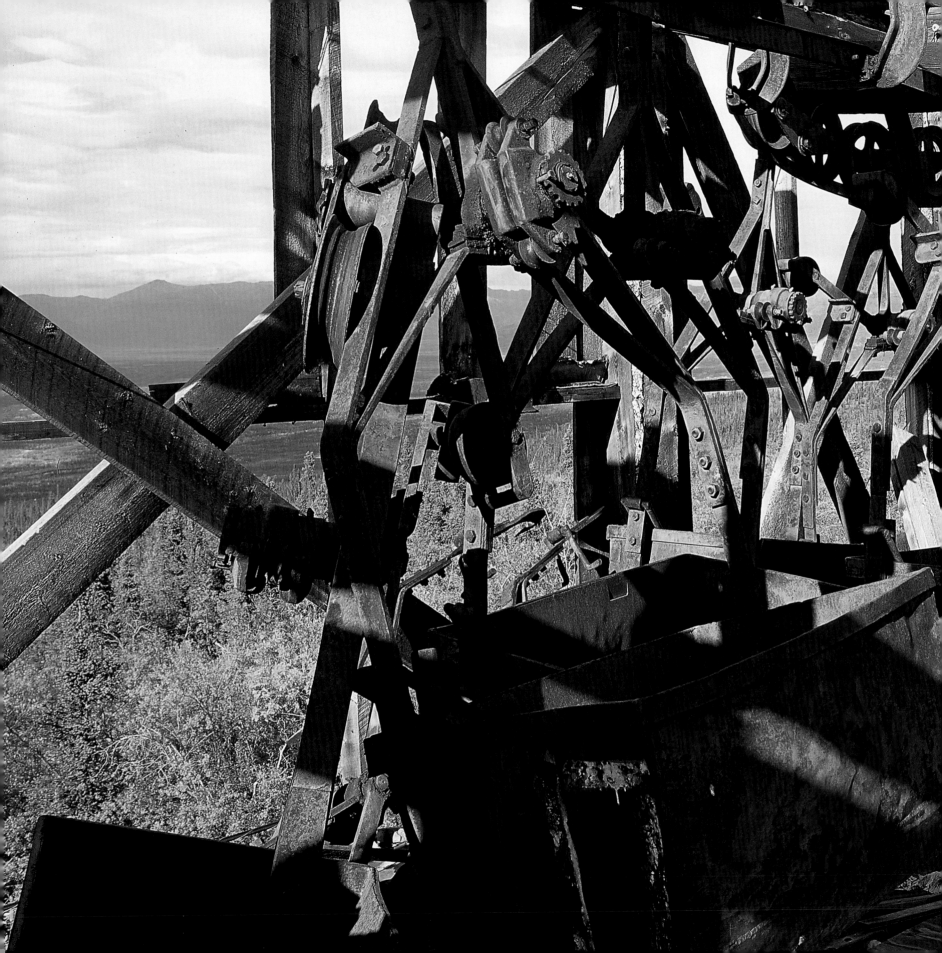

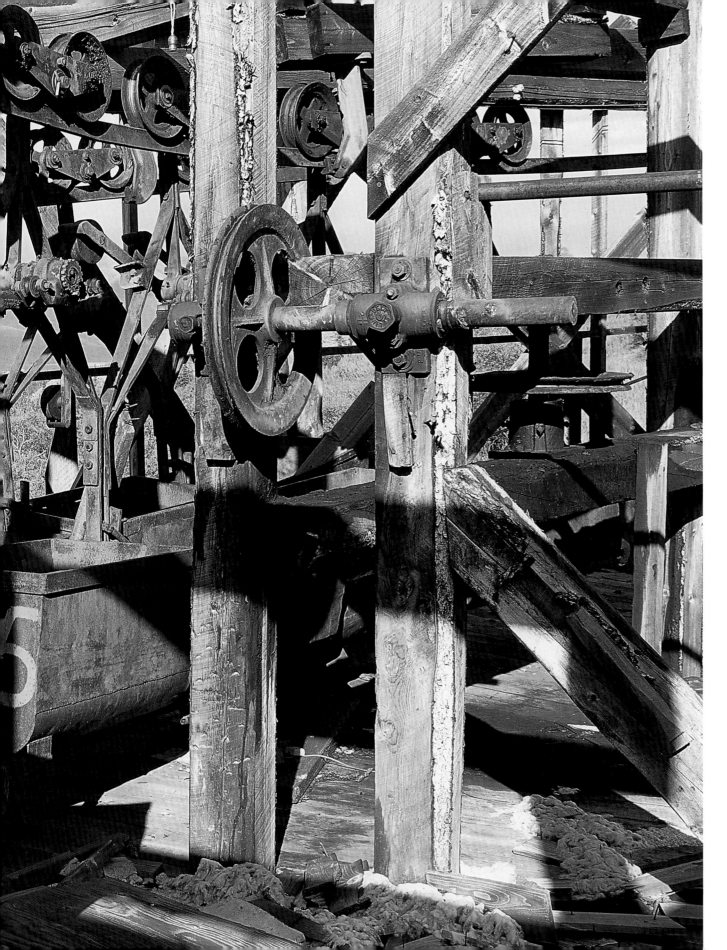

An old tram house remains on the hillside above the community of Elsa. As in many regions of the Yukon, mining continues here. However, new technologies allow companies to extract ore without employing many labourers.

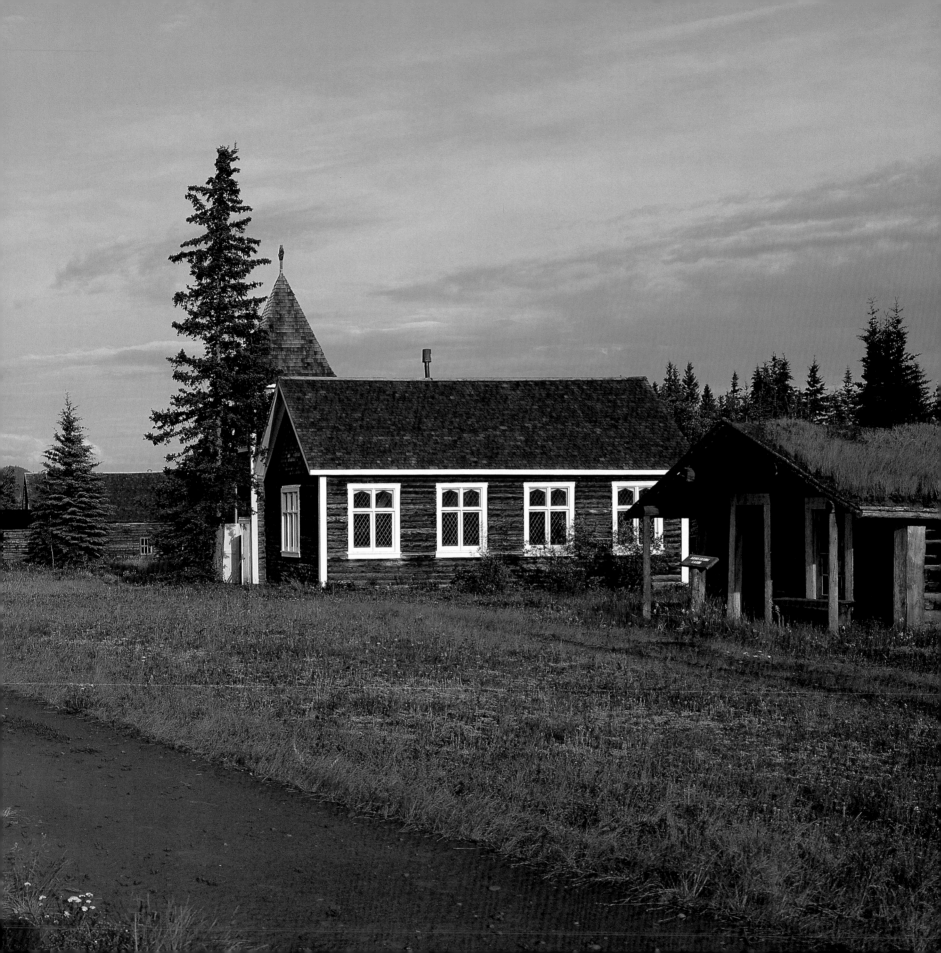

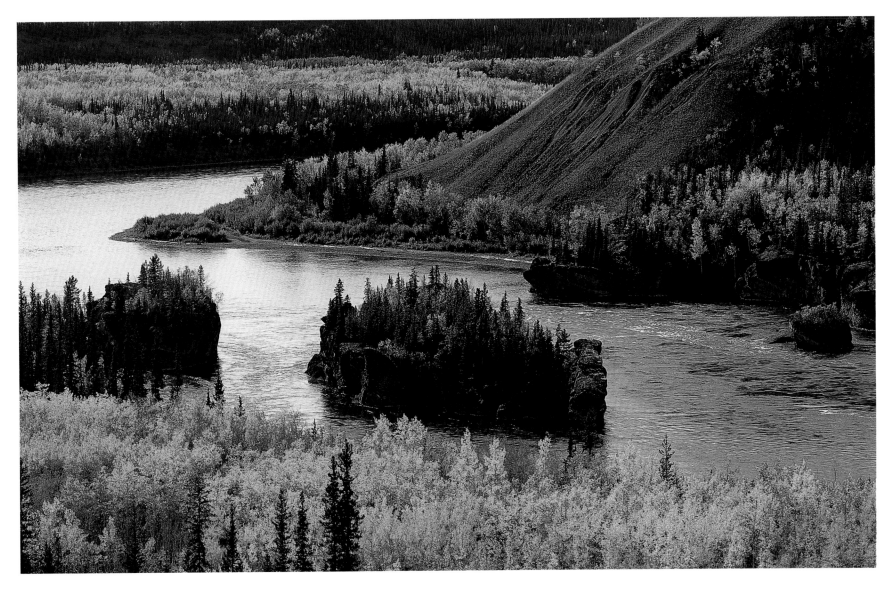

Four massive rock columns divide the Yukon River at Five Finger Rapids, once a hazardous part of the sternwheelers' route from Dawson to Bennett Lake. Kayakers and rafters now challenge the rapids while sightseers watch from viewpoints above.

Built in 1810 by the Hudson's Bay Company and abandoned due to flooding, Fort Selkirk was rebuilt, only to be pillaged by the Chilkats, rivals in the fur trade at the time. A third post was built in 1889 and served as a base for the Yukon Field Force and the Hudson's Bay Company until 1950.

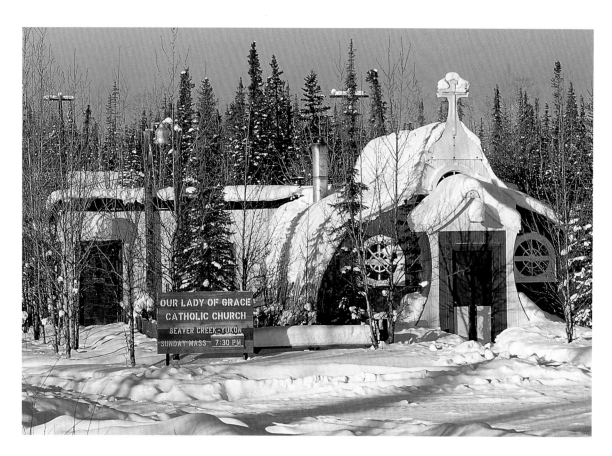

For centuries before the arrival of Europeans in the Yukon, the Upper Tanana people camped in this area each year as they travelled in search of food. Today, visitors pass through Beaver Creek as they approach the Alaska border.

Riverboats were once a common sight on the Yukon River near Carmacks, half way between Whitehorse and Dawson. Travellers on the Overland Trail found the small settlement near here a welcome refuge.

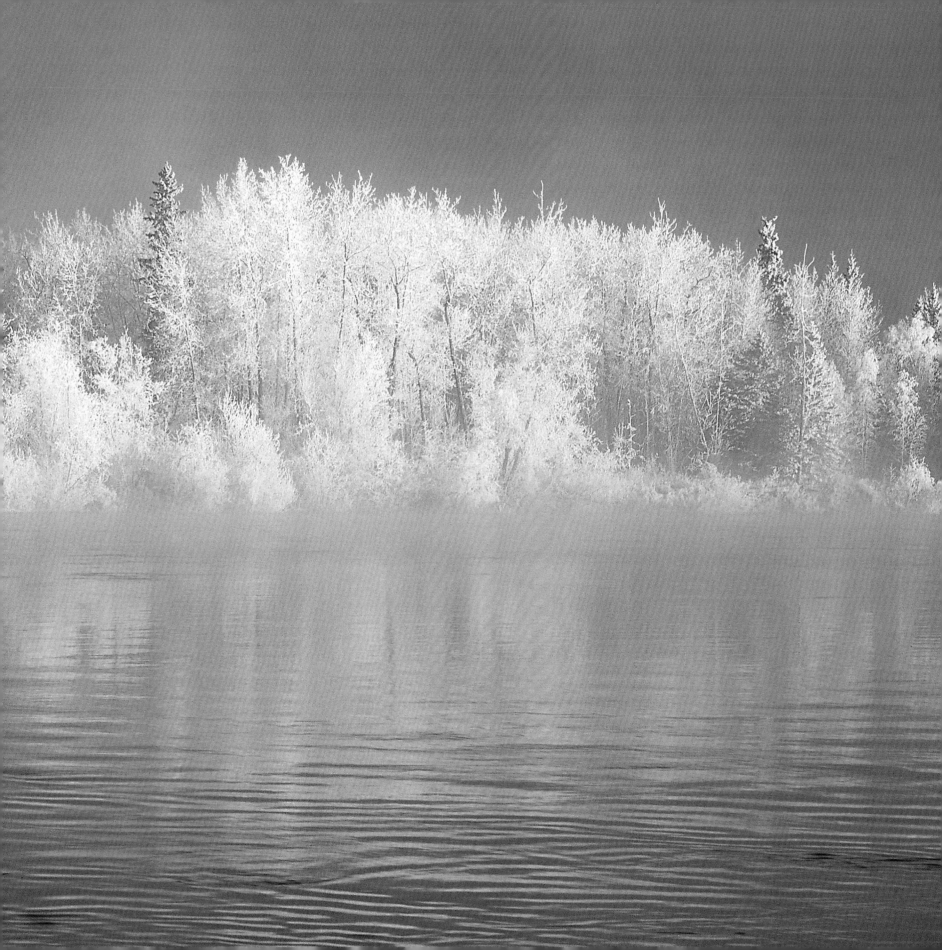

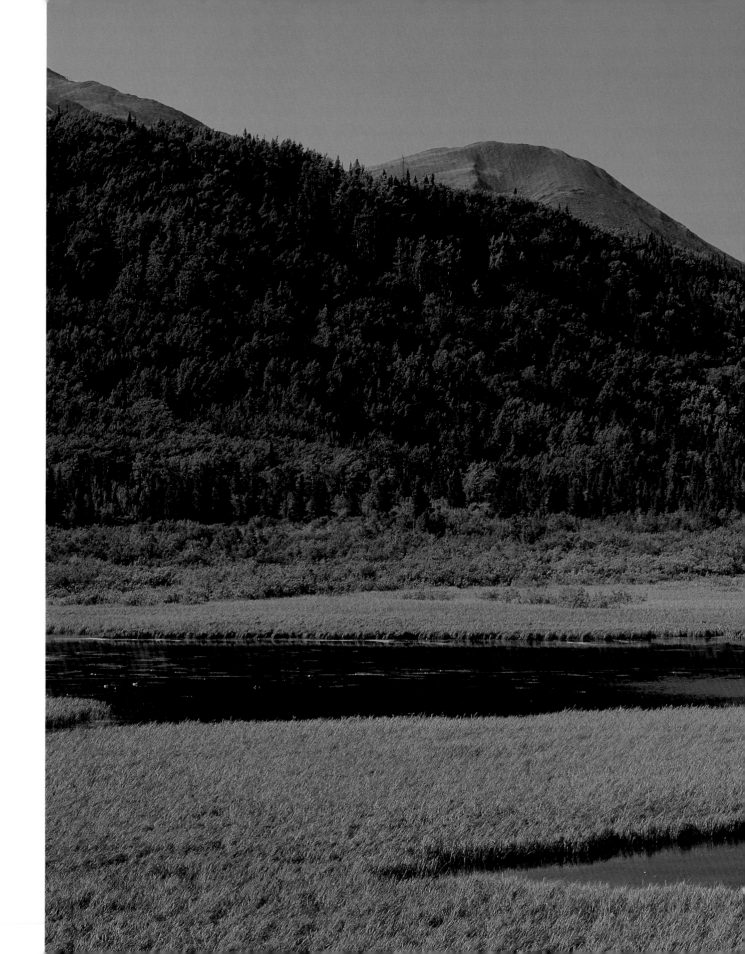

Haines Highway curls past some of southern Alaska's most spectacular sights, including Klukshu Lake. The road was originally built to transport supplies to crews working on the Alaska Highway.

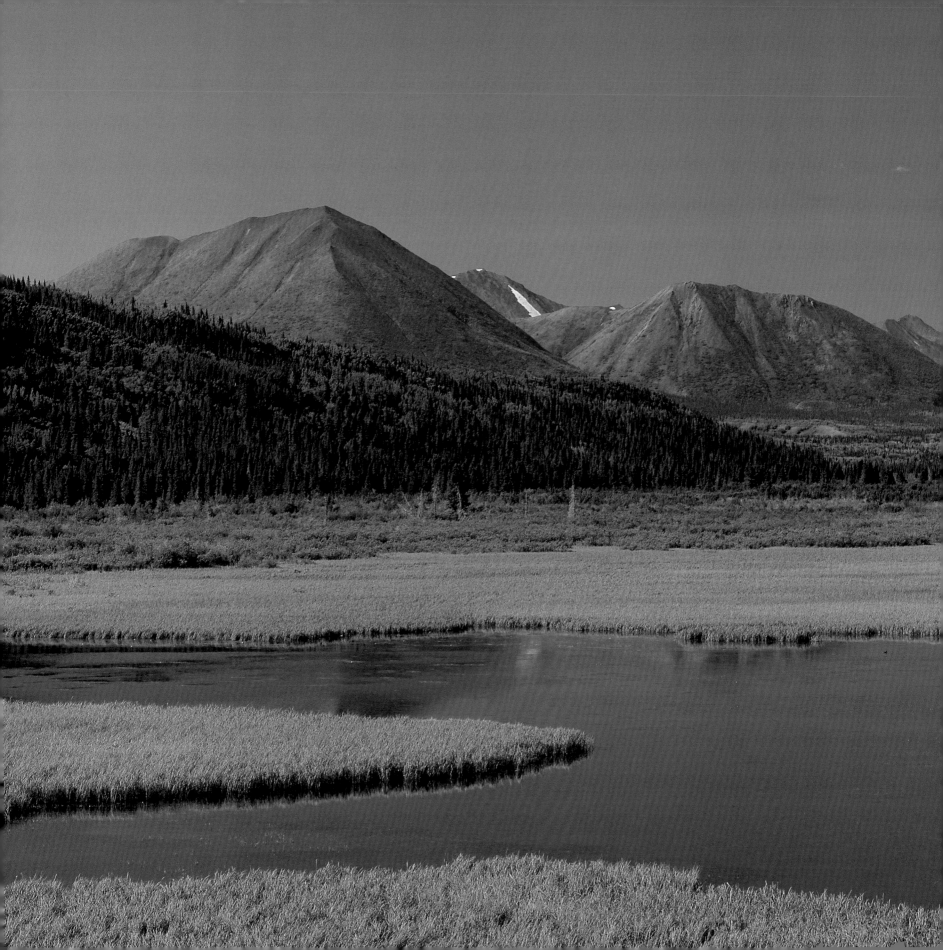

If this bald eagle seems to have noticed the photographer, it probably has. Its hearing is equal to human hearing, and its vision is four to eight times better. The eagles hunt and nest along lakeshores in the southern Yukon.

FACING PAGE—
The Alaska Highway skirts the shores of Kluane Lake, just outside Kluane National Park. The lake draws sport fishers from around the world, who vie for trophy lake trout.

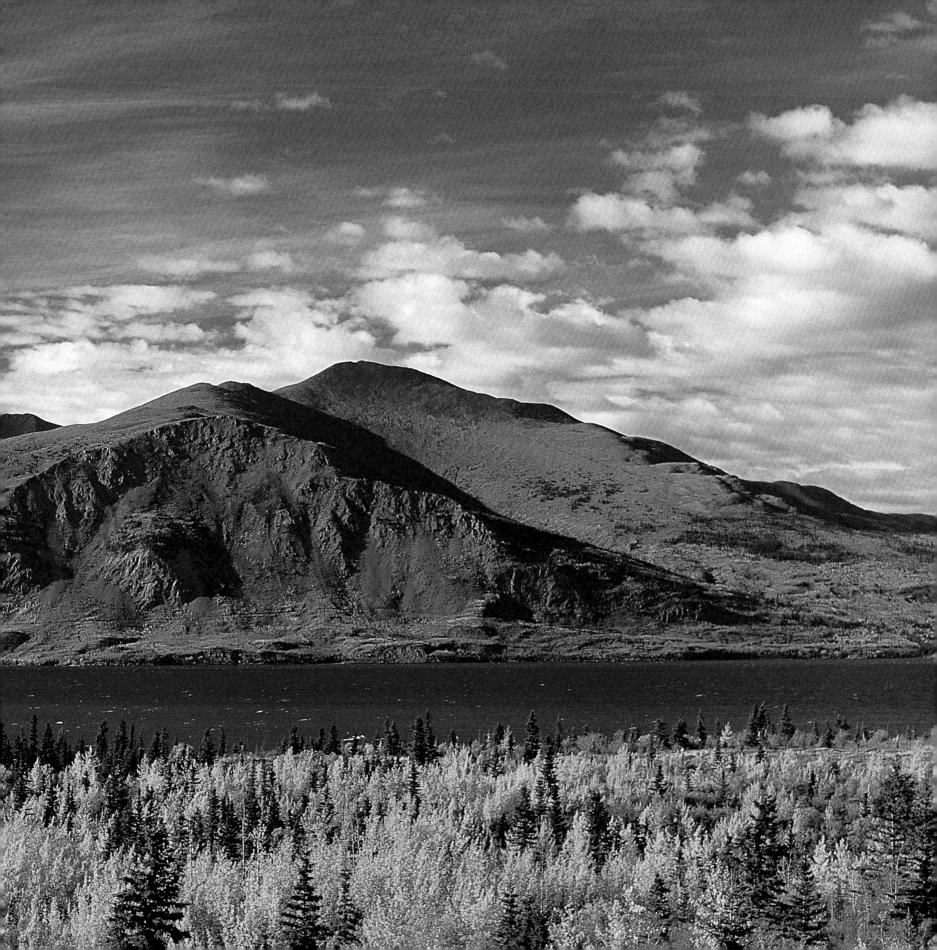

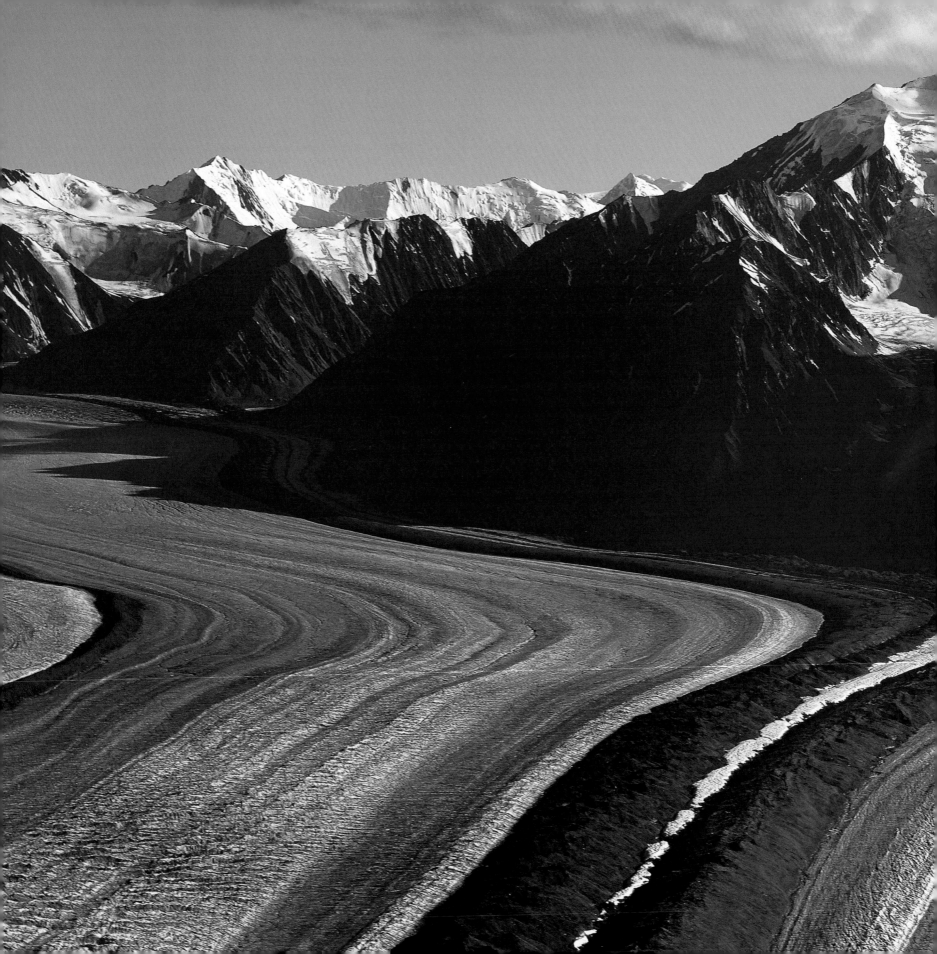

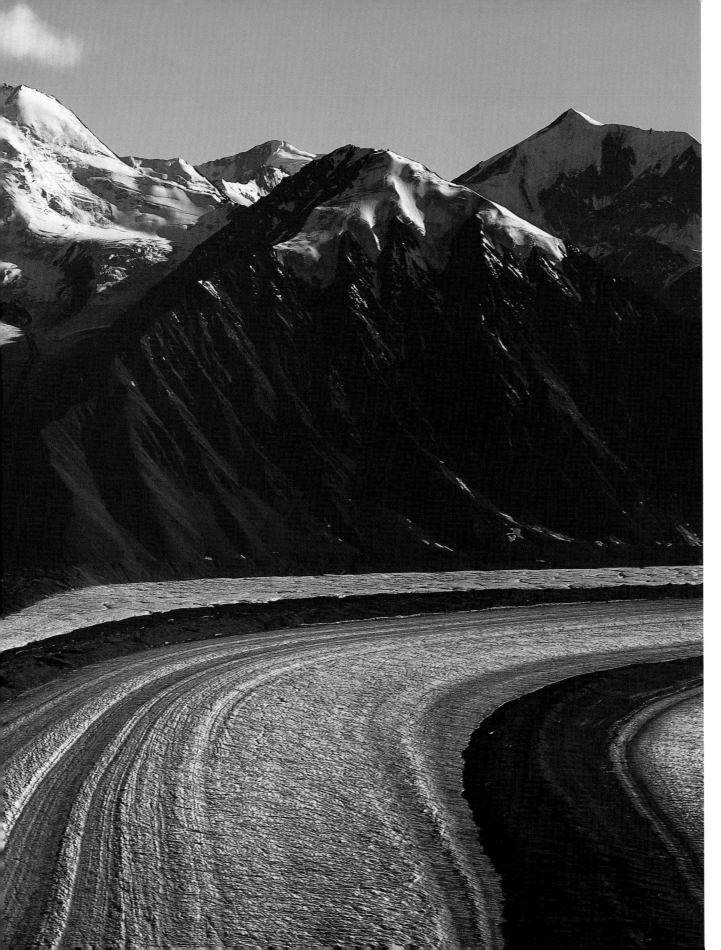

The St. Elias Mountains—the highest range in Canada—slice through Kluane National Park in the southern Yukon. Massive peaks and the largest non-polar icefields in the world account for more than 80 percent of the preserve.

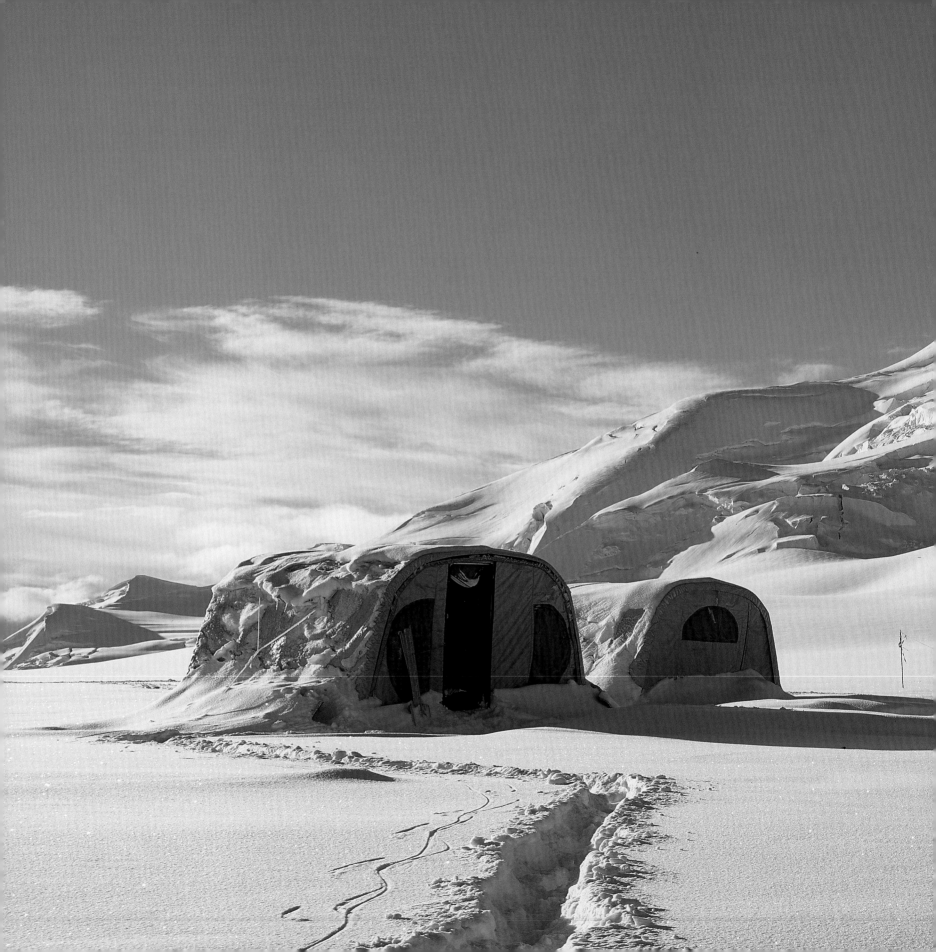

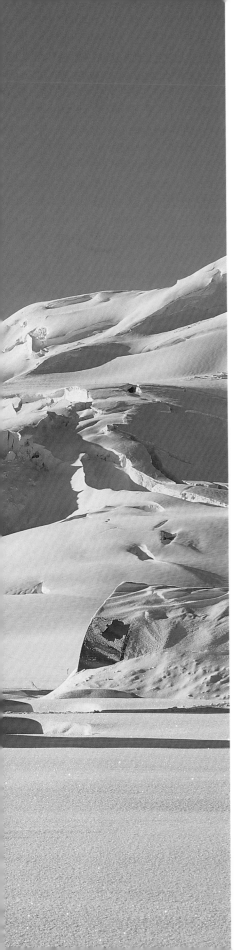

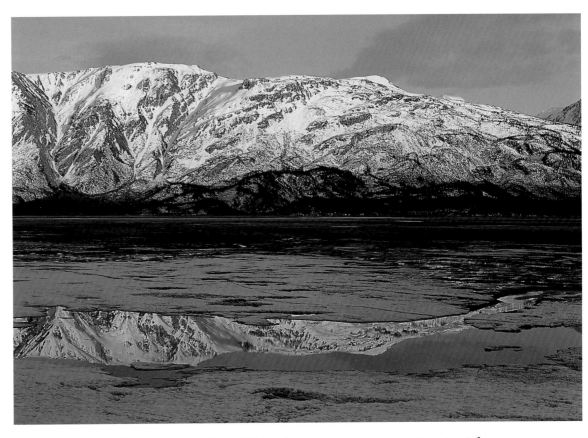

Below the treeline, more than 200 plant varieties survive in Kluane National Park, making this one of the most diverse ecosystems in Canada's north.

Mountaineers who challenge the high peaks in Kluane National Park face one to three weeks of intense, expert climbing. Winds of more than 100 kilometres (60 miles) per hour whip around the summits, and sudden snowfalls can leave teams stranded for several days.

Lupine and other wild-
flowers bloom in abun-
dance in the southeast-
ern portion of Kluane
National Park, where
the influence of the
Pacific Ocean ensures
a milder climate.

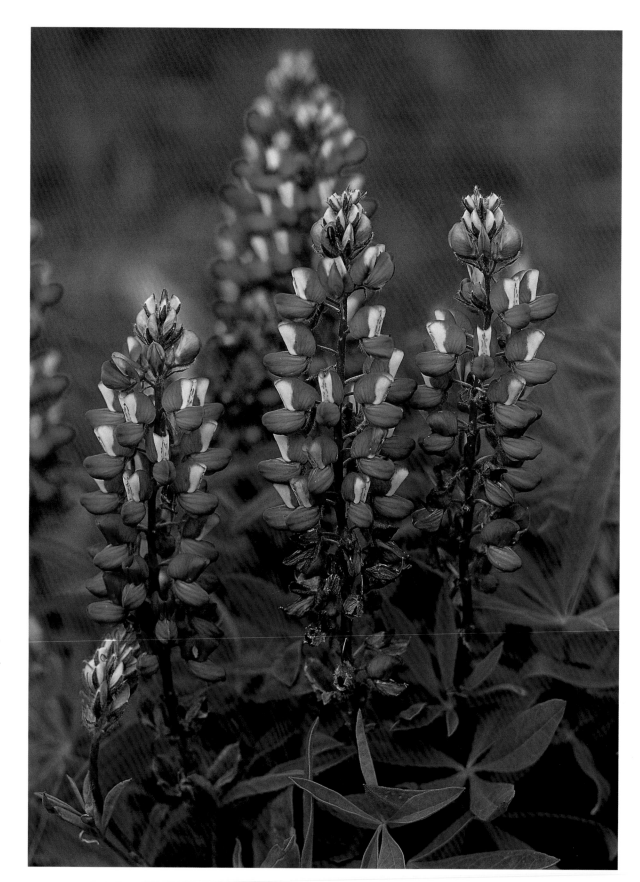

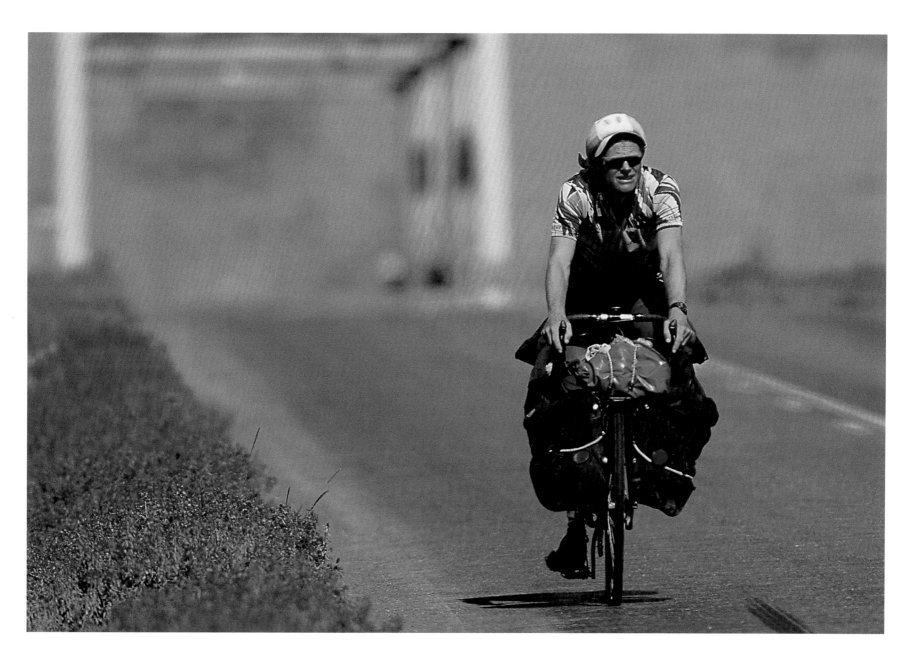

Kluane National Park adjoins Alaska's Wrangell-St. Elias National Park and Glacier Bay National Park, as well as British Columbia's Tatshenshini-Alsek Provincial Park. Together, they cover 8.5 million hectares (21 million acres), the largest international preserve in the world.

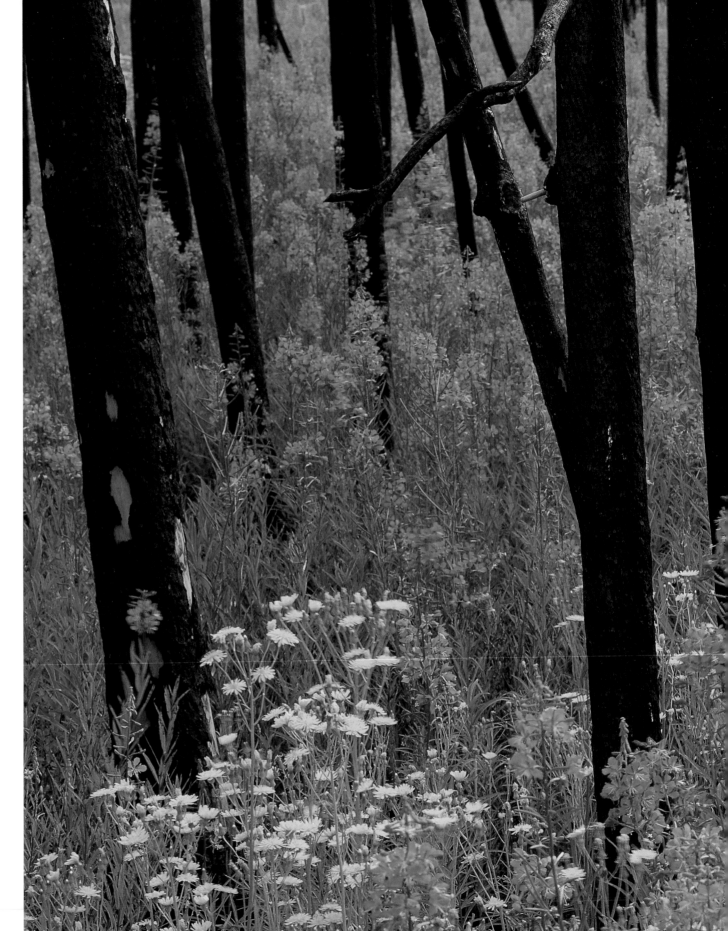

Fireweed, the Yukon's official flower, paints the landscape vivid pink. The flower is named for its ability to quickly spread over a forest fire site such as this one.

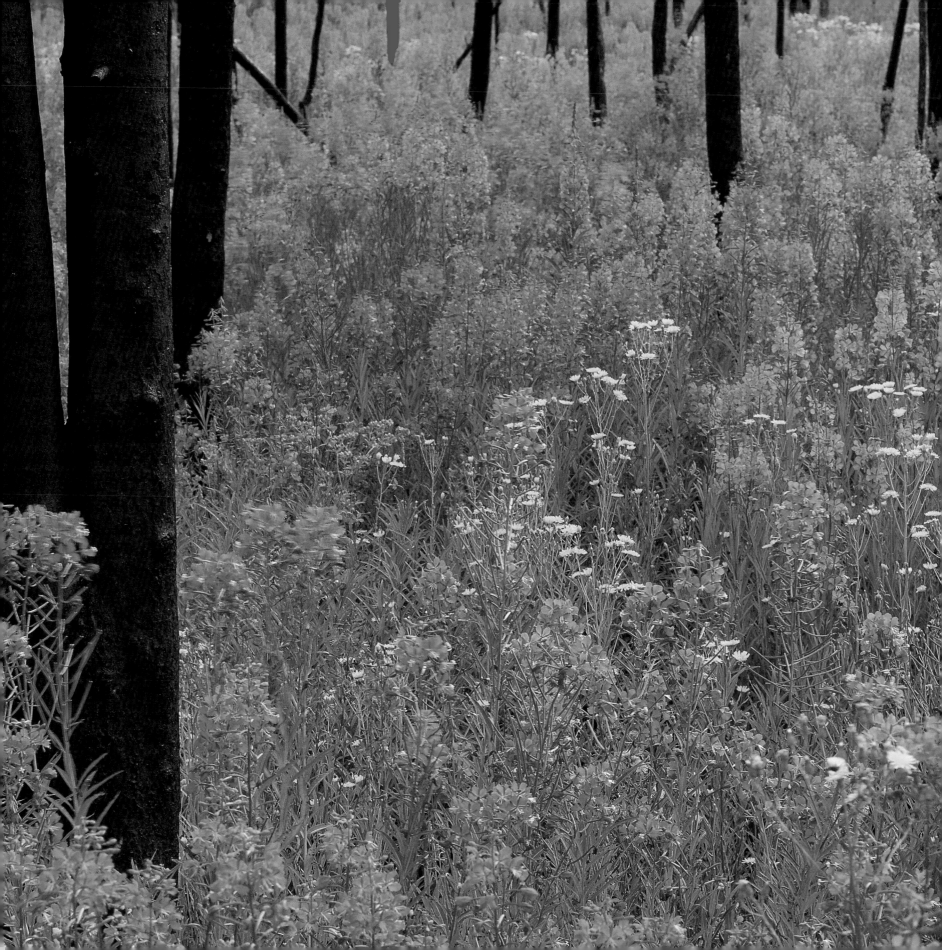

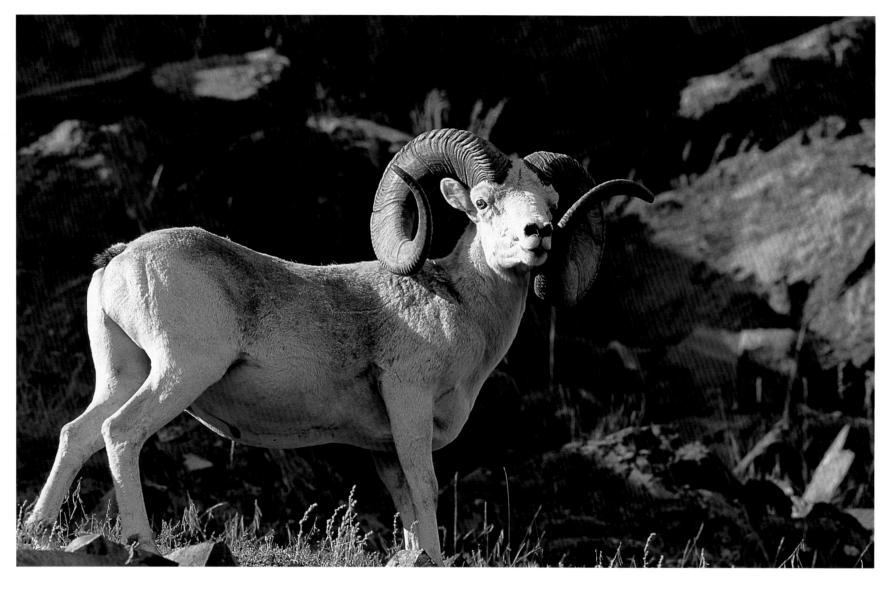

Scientists believe that mountain sheep travelled the Bering land bridge
from Asia half a million years ago. Those that now live in the north
are Dall sheep, with distinctively slender horns.

Lake Laberge earned fame for its role in Robert Service's poem
"The Cremation of Sam McGee." The poem's narrator cremates
McGee, on request, in the boiler of the *Alice May*, only to find him
alive and celebrating in the flames.

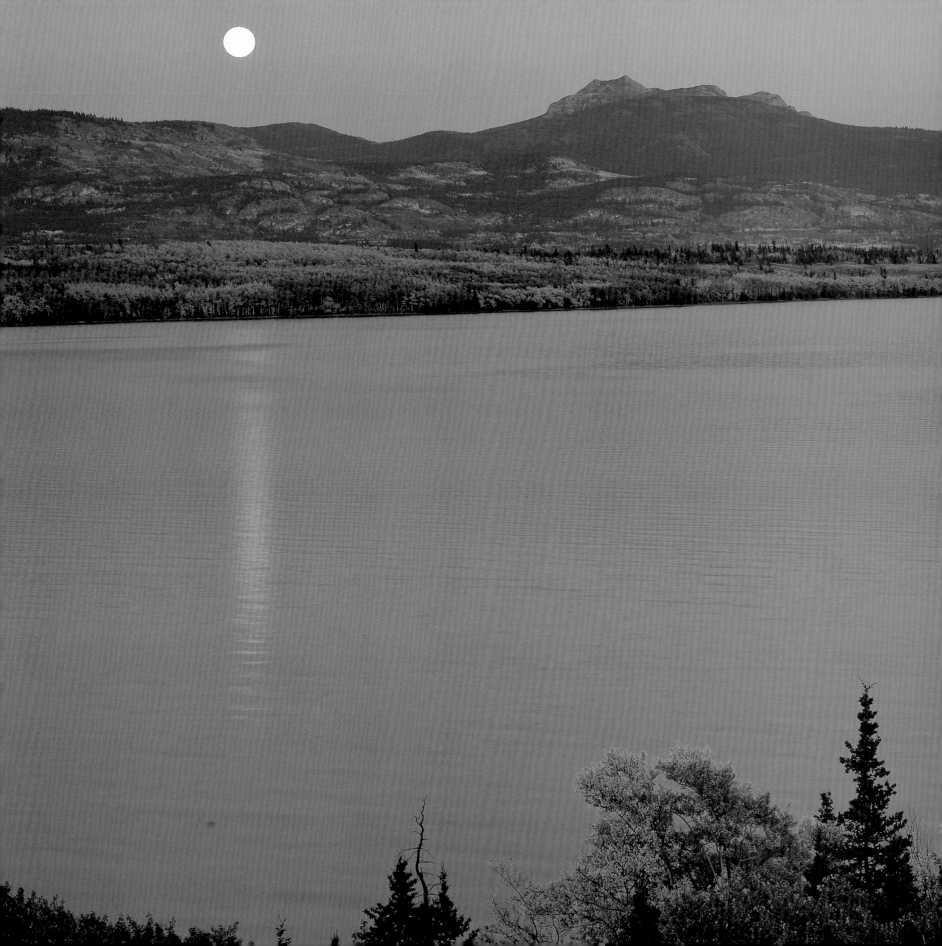

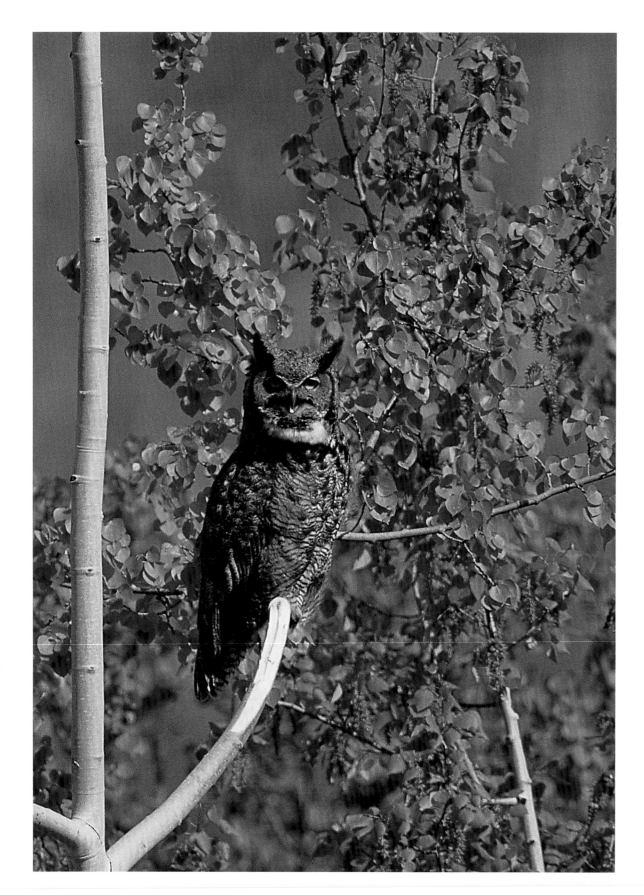

Easily identified by its ear tufts, or "horns," the great horned owl is one of North America's most common raptors and can live year-round in the Yukon's wilderness. Like many owls, these are nocturnal hunters, preying on rabbits, hares, grouse, and ducks.

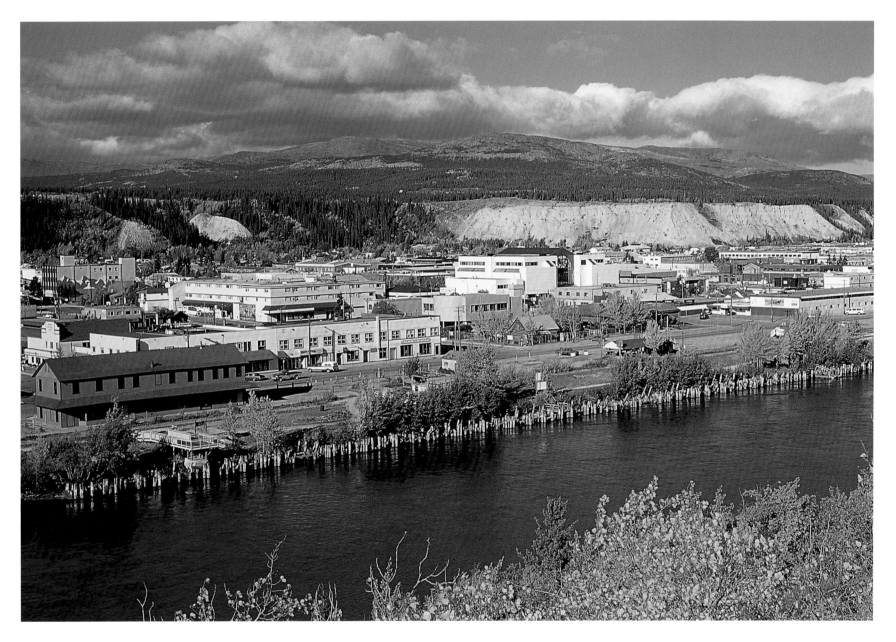

About two-thirds of the Yukon's population lives in Whitehorse, the territory's capital since 1953. The city began as a stopping point on the route to the gold rush. Then, during World War II, 3,000 members of the U.S. Army were stationed here to construct the Alaska Highway.

Built in 1929, the *S.S. Klondike*—the largest sternwheeler on the Yukon River—could carry 272 tonnes (300 tons) of cargo. Donated to the federal government once road access had rendered sternwheelers obsolete, the vessel has been restored and is now open to the public as the Yukon's most visited national historic site.

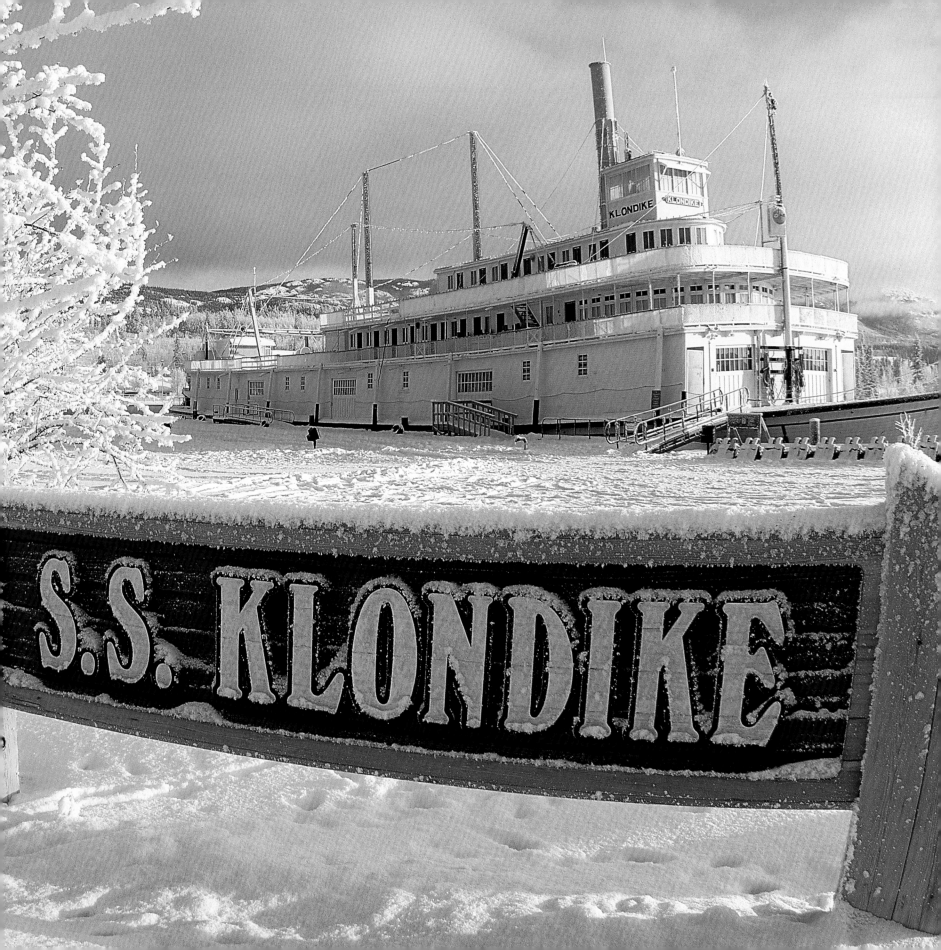

Whitehorse is named for the rapids along the Yukon River— those who first saw the churning water compared it to the manes of swift white horses. The same rapids forced the gold rush stampeders to a slower pace, and the settlement of Whitehorse was born on their route around the river.

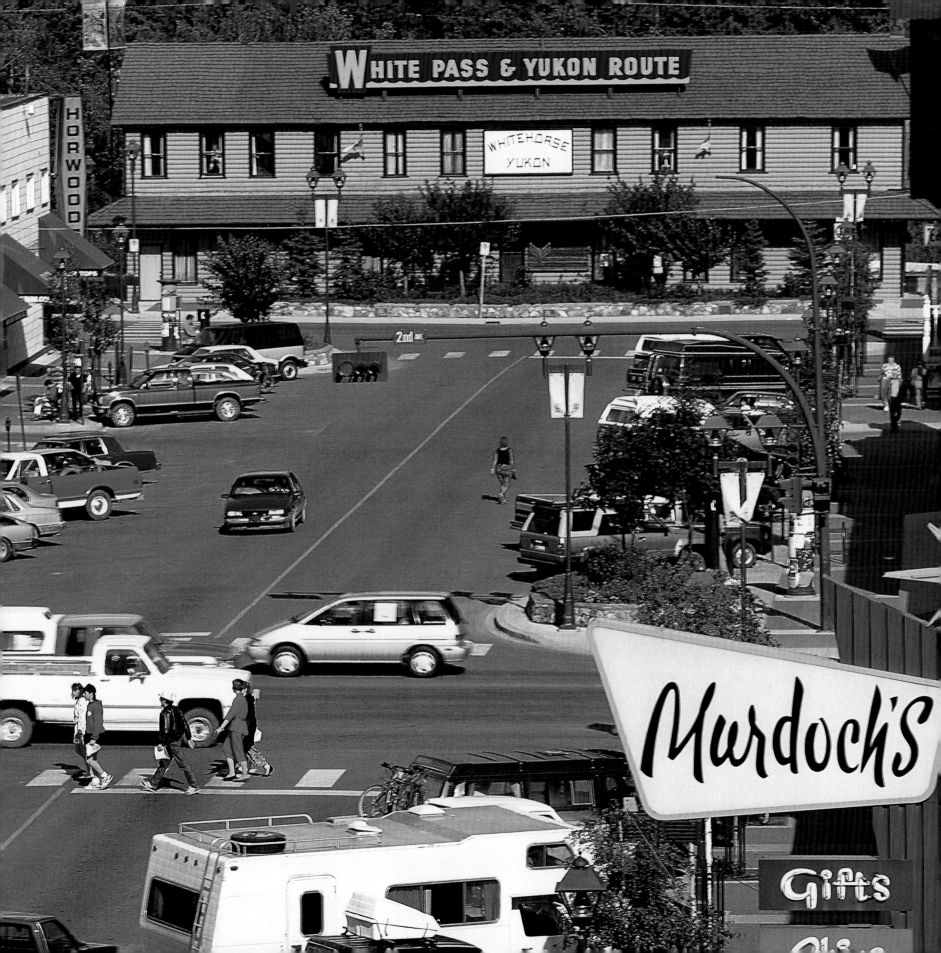

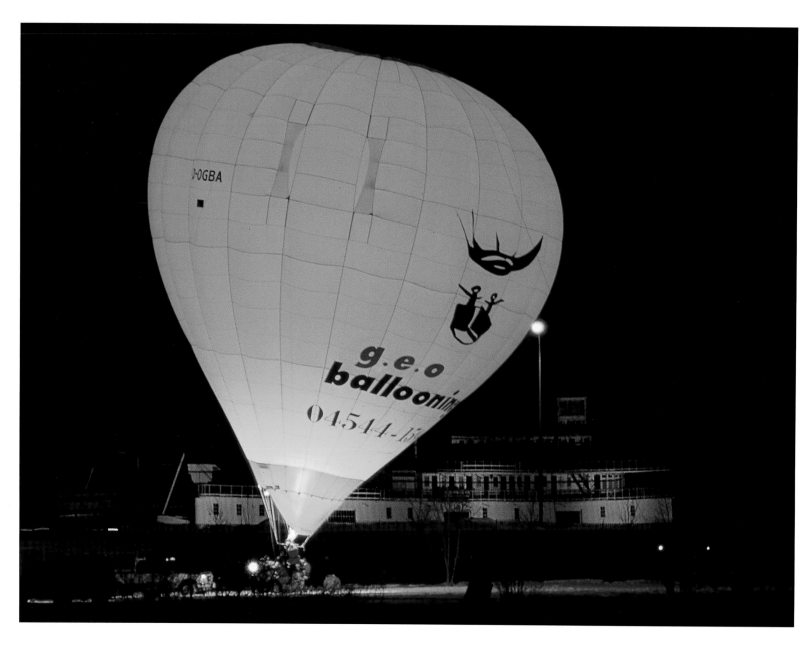

The cold, still winter air around Whitehorse draws balloon enthusiasts from across North America and Europe each winter. Balloonists must proceed with caution, however–if they drift off route, there are few access roads for groundcrews to follow.

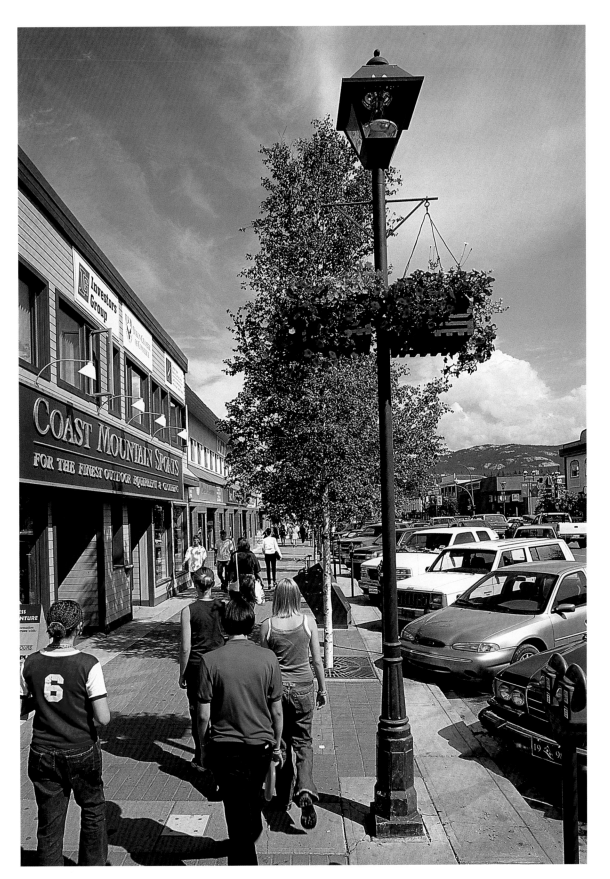

Tourism has grown to become the Yukon's largest private sector industry. Whitehorse, ideally located just off the Alaska Highway, boasts more than 20 hotels and daily flights to other Canadian and American cities, making it a natural hub for visitors.

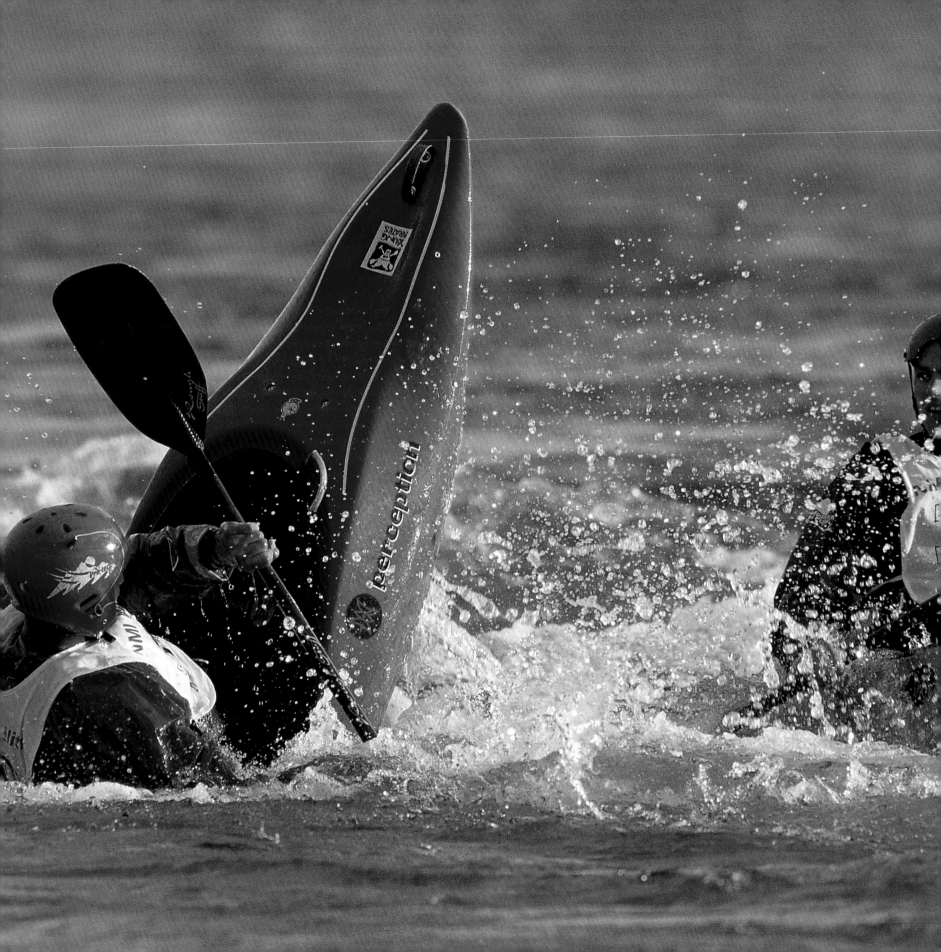

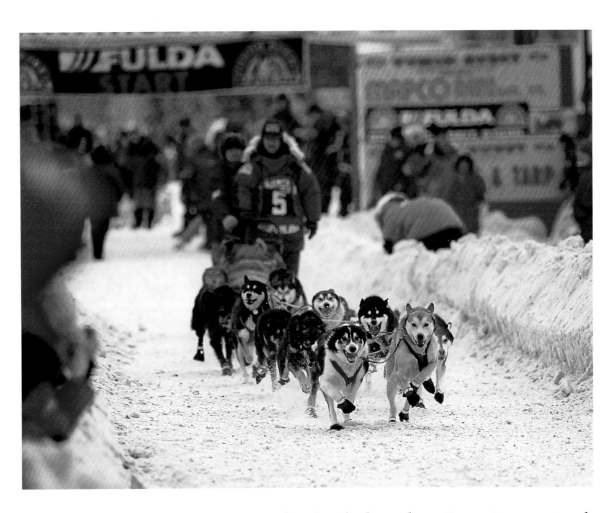

The world's most gruelling event of its kind, the Yukon Quest International Sled Dog Race leads teams on a 1,600-kilometre (1,000-mile) wilderness trek from Whitehorse to Fairbanks, Alaska. Mushers care meticulously for their teams, to ensure they complete the entire race.

At the annual Whitehorse Whitewater Rodeo, paddlers battle the current in slalom, freestyle, and down-river events. The freestyle event includes pops and spins, each trick intended to win the competitor additional points.

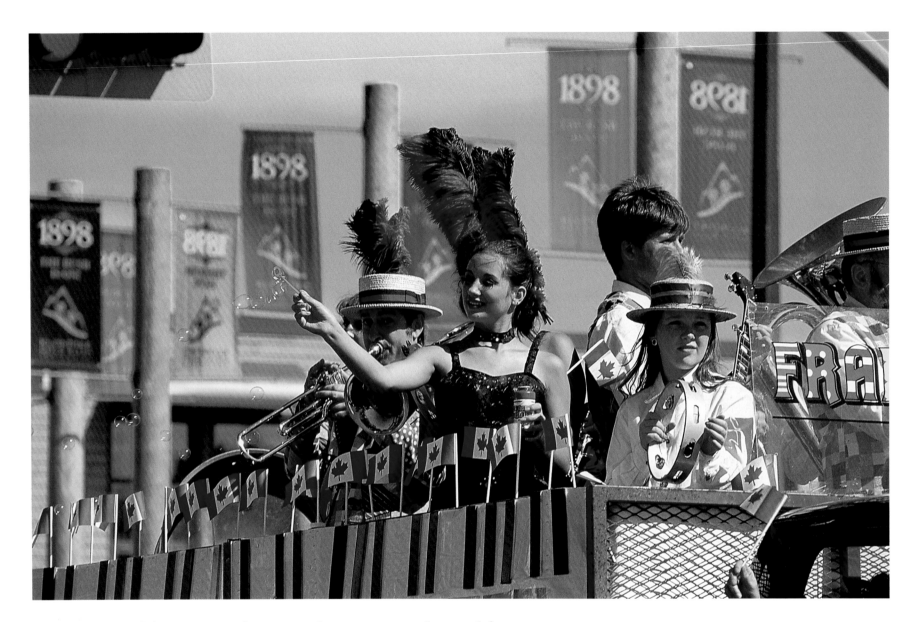

Whitehorse celebrates Canada Day with events, parades, and fire-works. The Yukon was passed from the Hudson's Bay Company into the control of the Canadian government in 1870, as part of the Northwest Territories. The government declared it a separate territory in 1898.

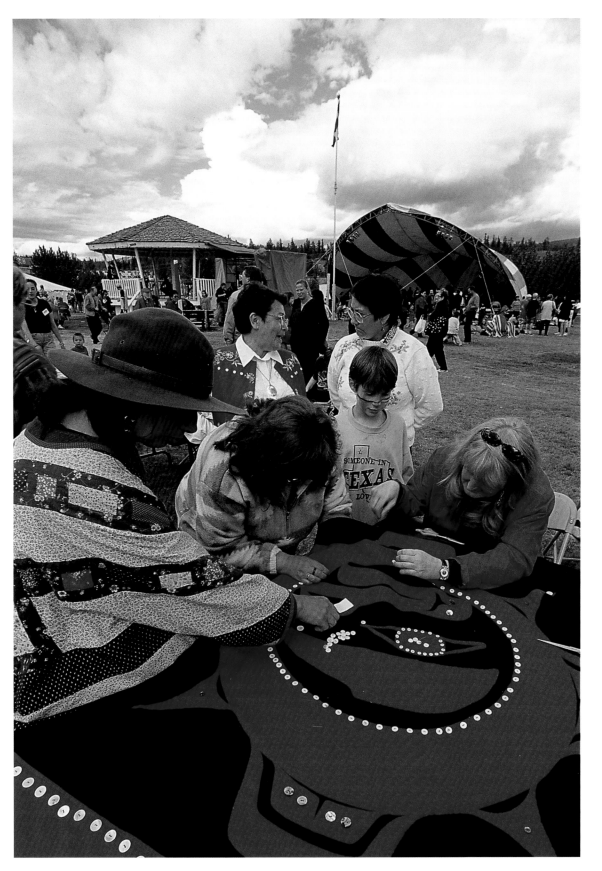

When the natives of the Pacific Coast first met European traders, women began to incorporate pearl buttons into their traditional shell and fabric patterns. Today, the intricate designs of the button blankets have gained recognition from artists and collectors across the continent.

Cycling season is over as the first snowfall carpets Whitehorse. Much of the Yukon enjoys only about 75 frost-free days each year, making the snowmobile, rather than the bicycle, the favoured means of transportation.

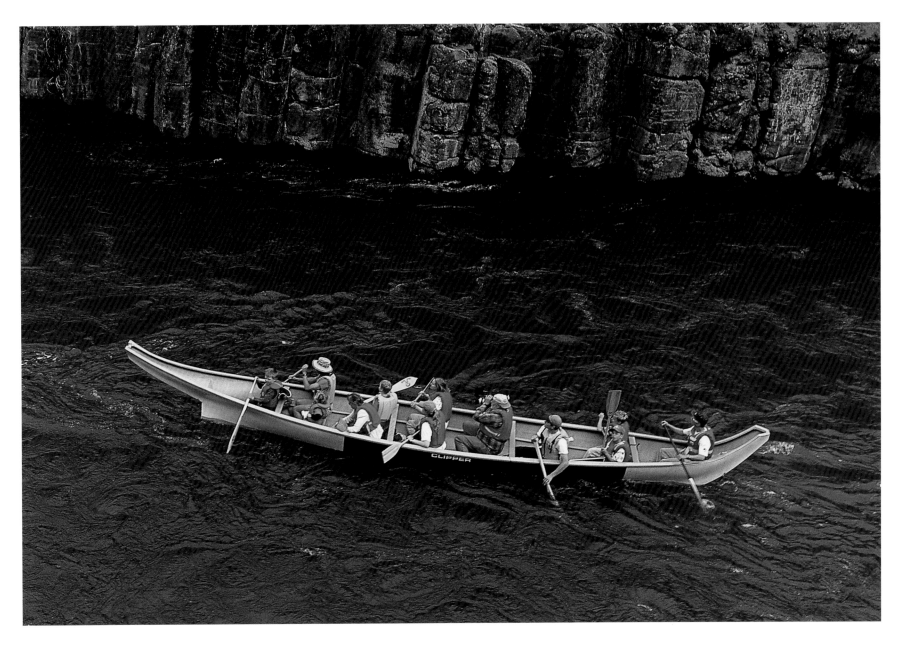

Before the North-West Mounted Police arrived and imposed safety standards, more than 150 boats were destroyed by the rapids in and around Miles Canyon in 1897. Since 1958, the waters have been tamed by the Whitehorse hydroelectric dam.

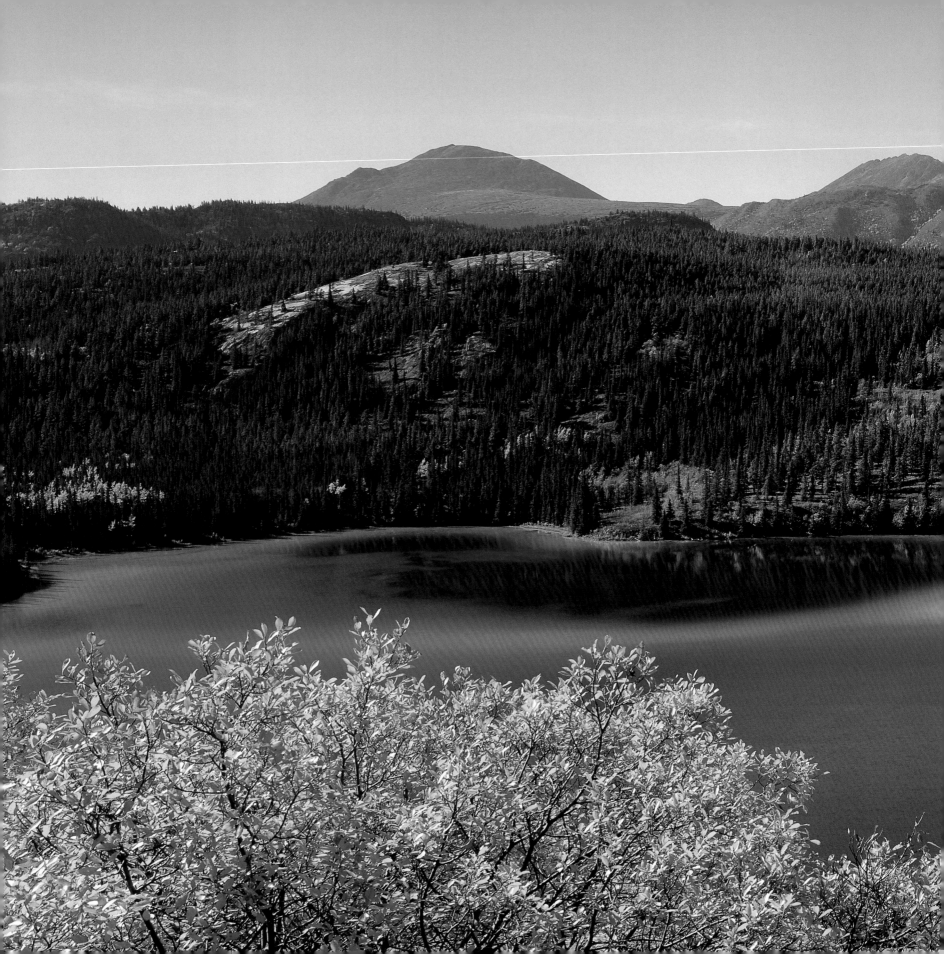

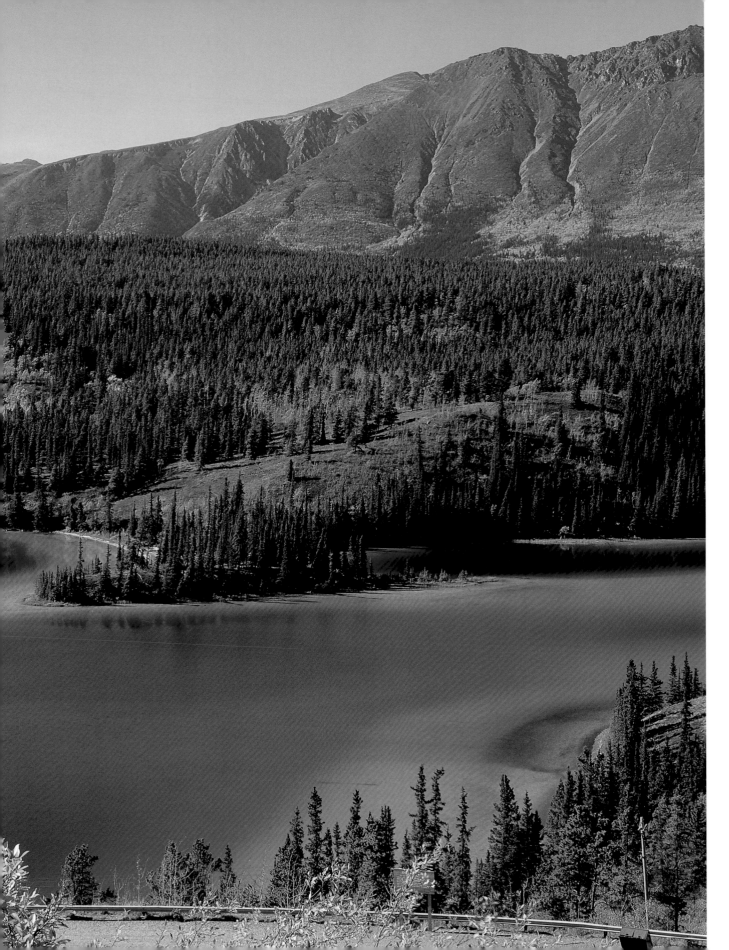

Emerald Lake sparkles in the sunshine near Carcross. Carcross, short for caribou crossing, is named for the herds of animals that once migrated across this region.

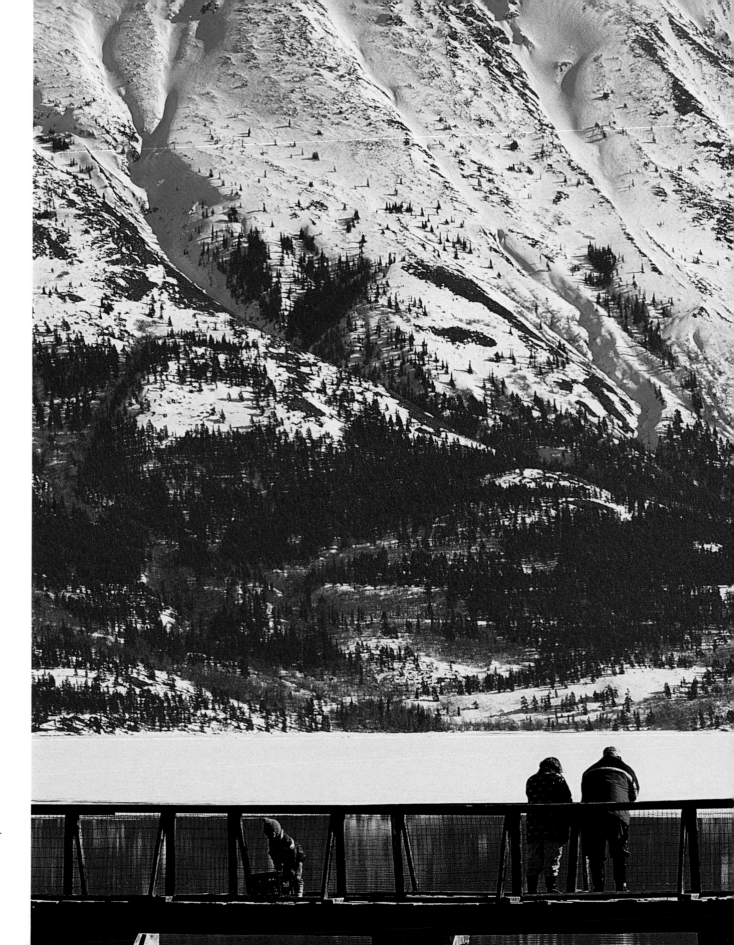

From its source at Bennett Lake, the Yukon River flows more than 1,140 kilometres (680 miles), draining half the Yukon before churning across the Alaska border. It empties into the Bering Sea after another 2,060 kilometres (1,240 miles).

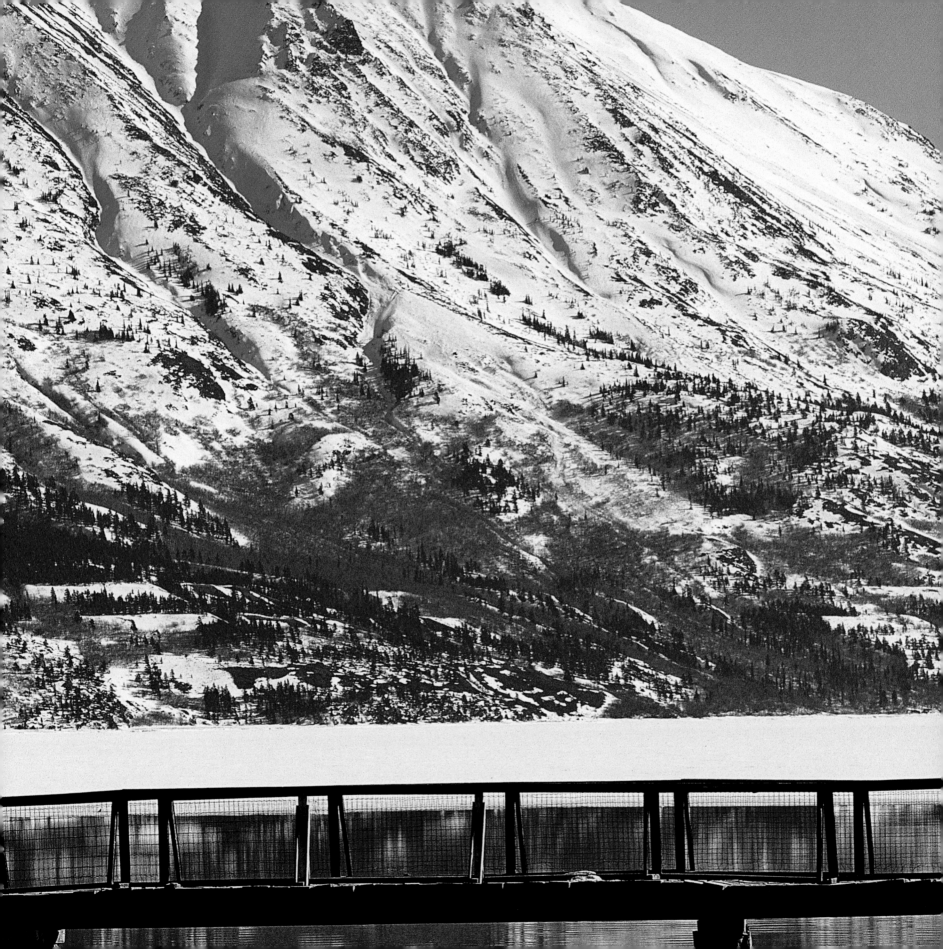

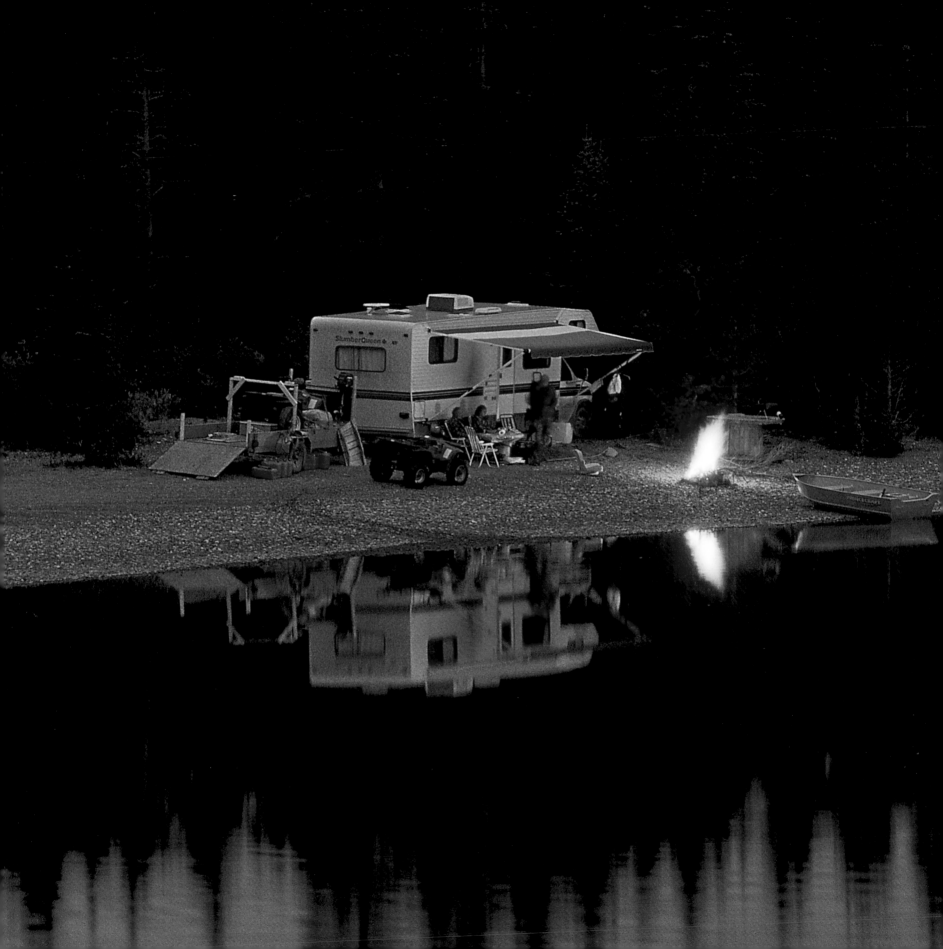

Thousands of campers
arrive in the Yukon
each summer. Some
find secluded campsites
on the riverbanks.
Others join guided
camping tours along
some of the territory's
famous highway routes.

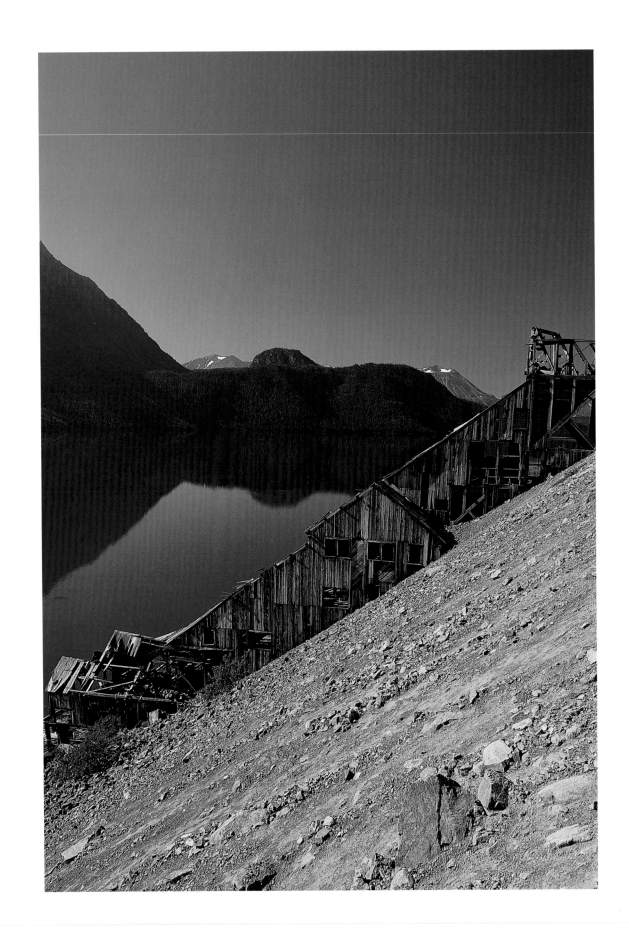

The Klondike Highway, built in 1978, winds by a deserted mine on its path from Skagway to the junction with the Alaska Highway just south of Whitehorse.

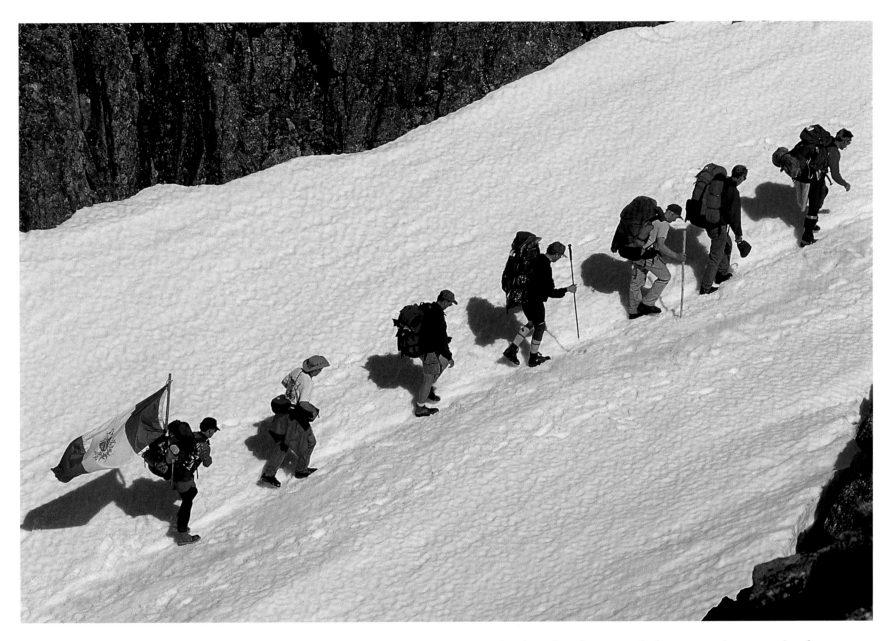

Prospectors in 1898 had to haul 1,000 kilograms (one ton) of supplies, making up to 100 trips over the gruelling 53-kilometre (33-mile) Chilkoot Trail. Today, hikers arrive prepared for any conditions—even snow in July—and conquer the trail in three to five days.

The vision of rail
builder Michael
Heney, the White
Pass and Yukon
Railway links
Skagway, Alaska, with
Whitehorse. Heney
began construction
on May 28, 1898,
convinced the line
would be a vital link
to the gold fields as
well as a tourist
attraction.

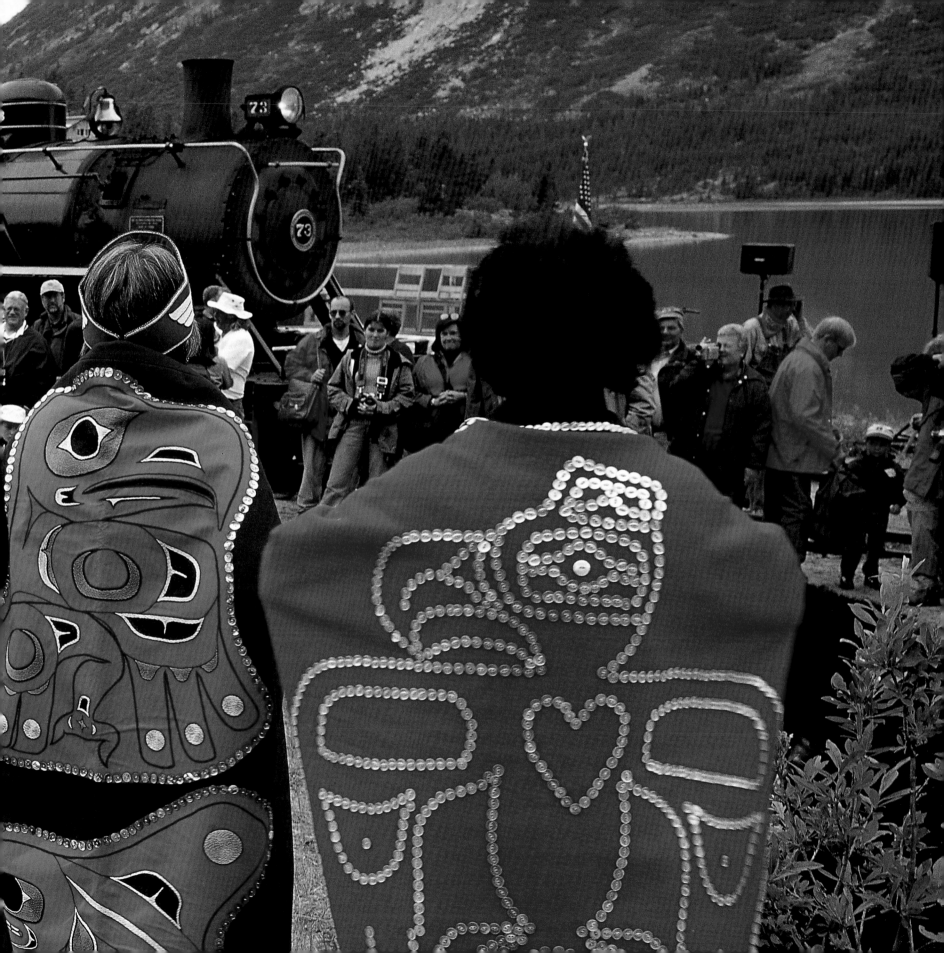

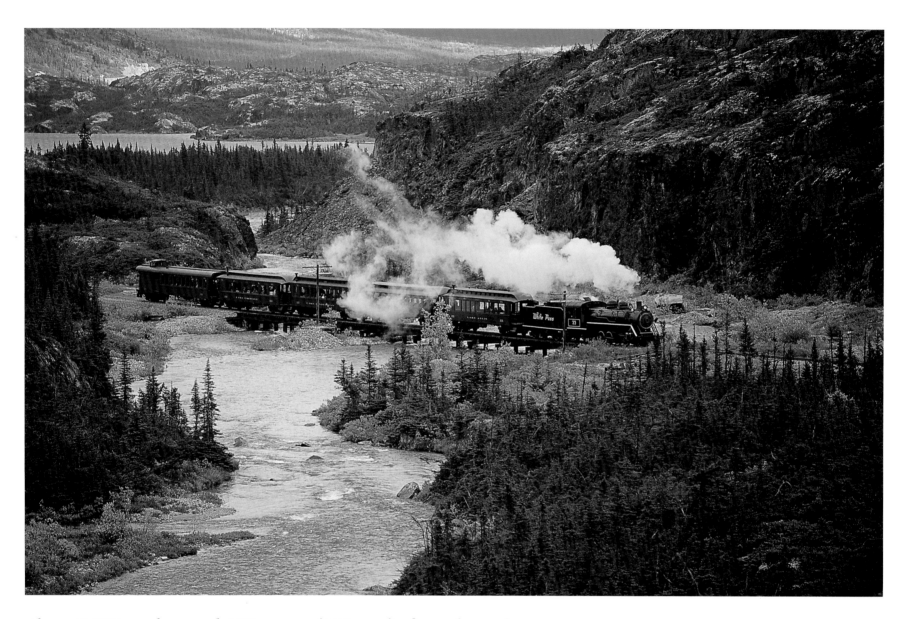

About 2,000 workers and 450 tonnes (495 tons) of powder and
dynamite were needed to force a path for the railway through the
coastal mountains. Aided by the long hours of daylight, crews
worked around the clock, and the first locomotive climbed to
the summit on February 20, 1899.

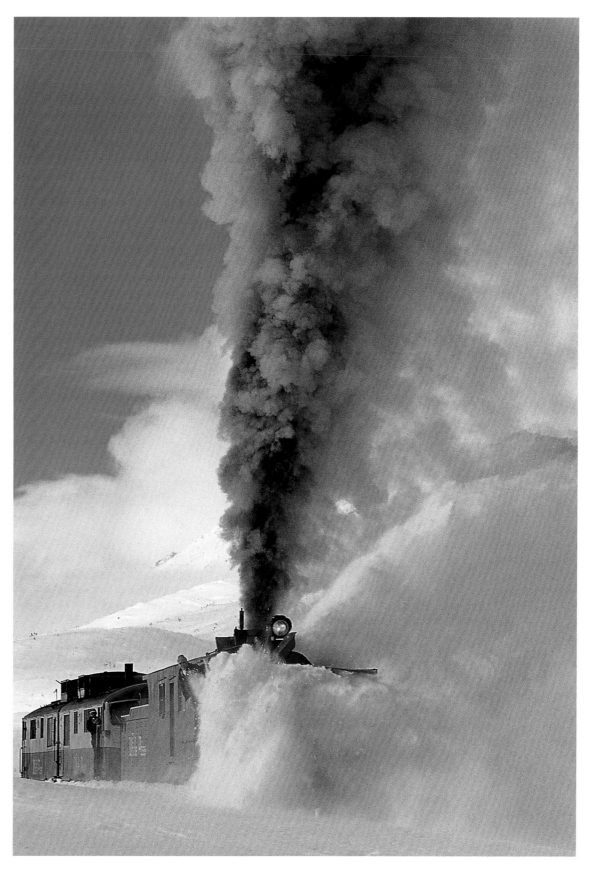

Railway enthusiasts gather each spring to see one of North America's two rotary snowplows at work on the tracks of the White Pass and Yukon Route Railway. Snowdrifts more than 6 metres (20 feet) deep can blanket the narrow-gauge line.

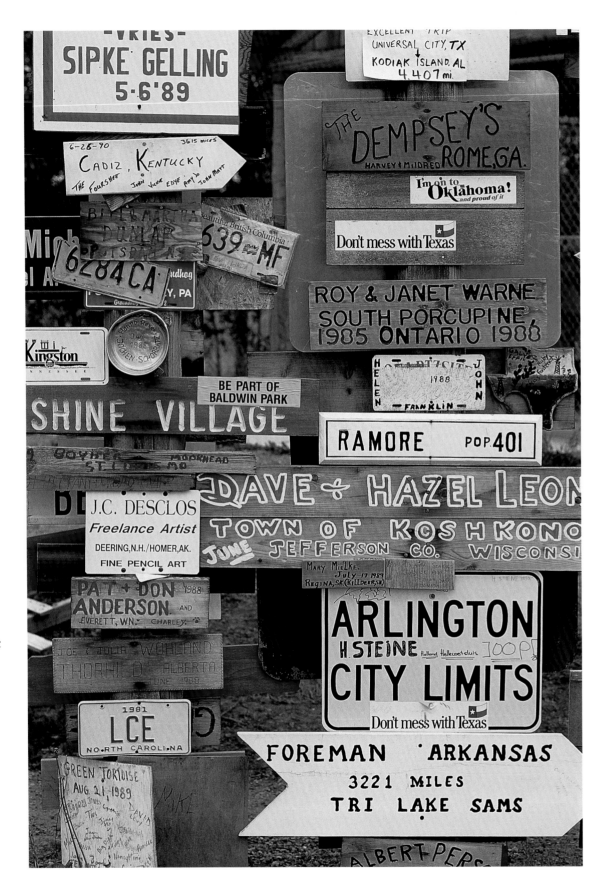

In 1942, Carl L. Lindley hung a sign in Watson Lake pointing to his hometown of Denville, Illinois. More than 50,000 travellers have since followed his example, creating a signpost forest with directions to cities around the world.

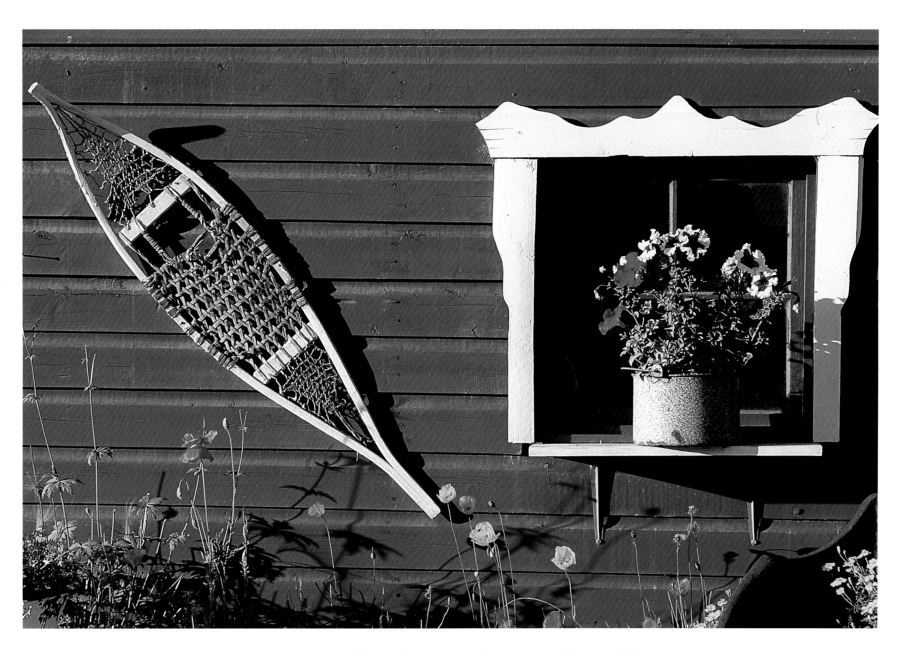

The Yukon's weather ranges from mild summers to extreme winters. The average January temperature ranges from -18°C to -26°C (0°F to -15°F), but lows can reach a bone-chilling -60°C (-60°F).

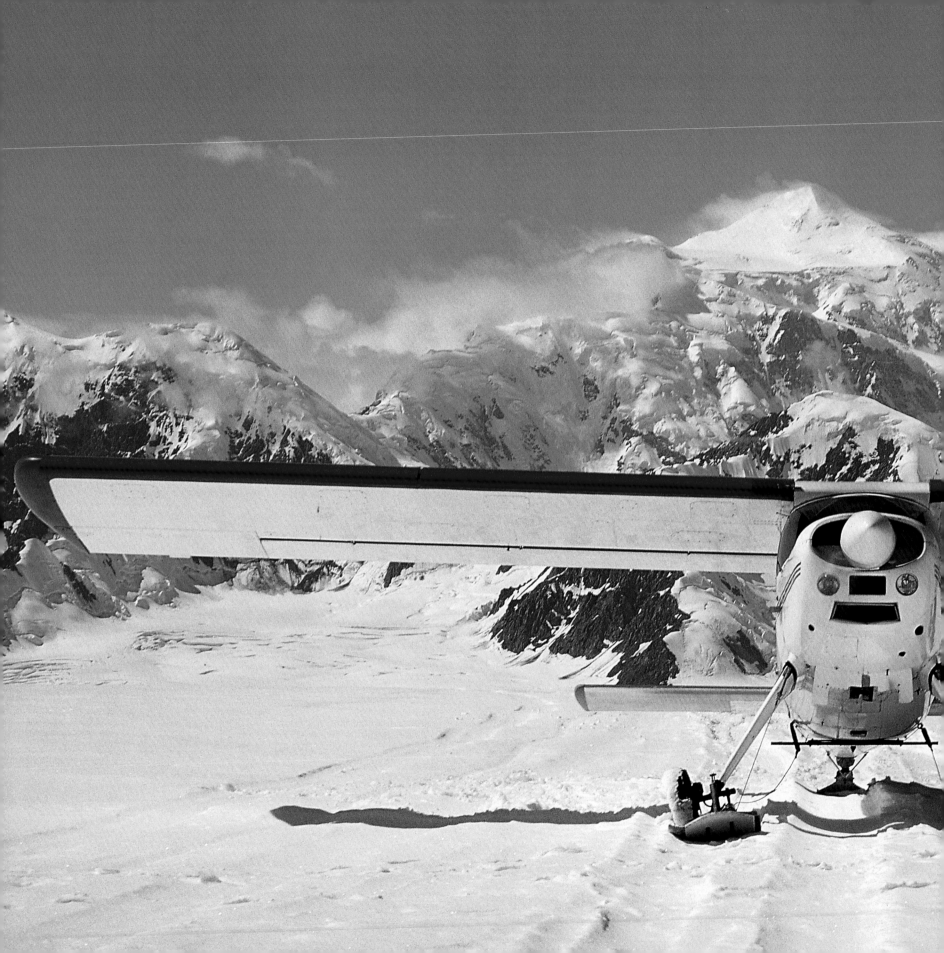

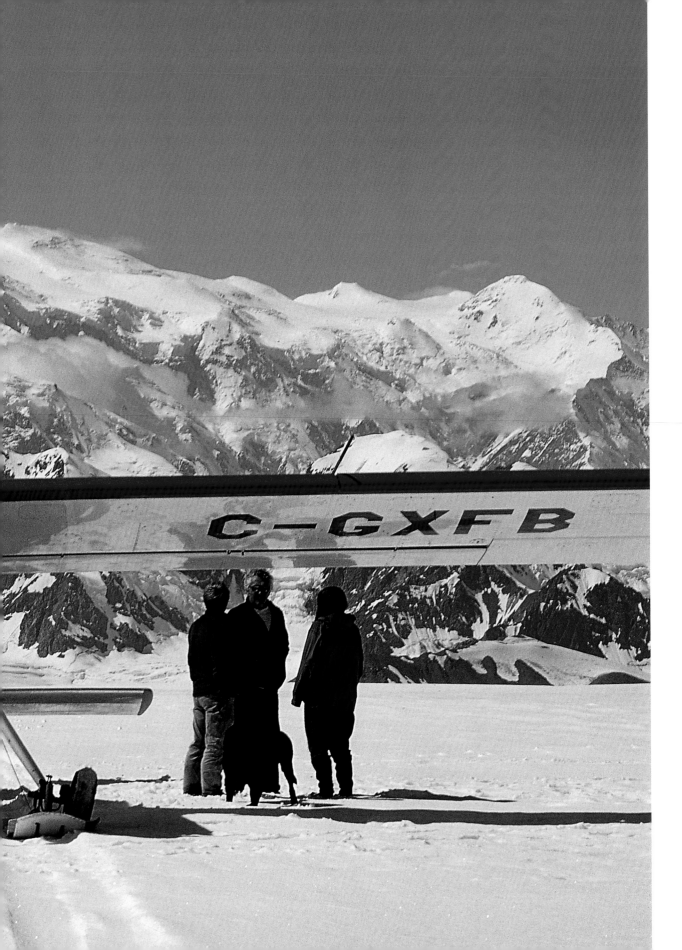

Canada's highest peak, Mount Logan towers 5,959 metres (19,550 feet) above sea level. It is named for Sir William Edmond Logan, a geologist and the director of the Geological Survey of Canada from 1841 to 1869.

Photographer Biography

Richard Hartmier came north to the Yukon from his native Ontario in the 1970s and, captured by the territory's gold rush history, its frontier spirit and its awe inspiring landscape, he never left.

In the last 25 years, he's flown, snowmobiled, hiked, boated and skied to its farthest-flung corners to photograph the Yukon's wildlife, people and landmarks.

His work has appeared in tourism campaigns and has been used in many books and popular magazines.

Hartmier is a member of the ASMP and his work is represented by First Light, a leading Canadian photo stock house.

He lives with his cocker spaniel Lindy in a quiet Whitehorse suburb with a view of the mountains.

This is his second book.